IMAGES
of America

MAPLE SHADE

On the cover: This is a photograph from about 1900 of the Pennsylvania Railroad passenger station that was built in 1874. The man at right is Harry Gilbert, who worked as an agent from 1893 to 1924. (Courtesy Frank Kozempel.)

Maple Shade Historical Society

Copyright © 2008 by Maple Shade Historical Society
ISBN 978-0-7385-5492-1

Published by Arcadia Publishing
Charleston SC, Chicago IL, Portsmouth NH, San Francisco CA

Printed in the United States of America

Library of Congress Catalog Card Number: 2007927703

For all general information contact Arcadia Publishing at:
Telephone 843-853-2070
Fax 843-853-0044
E-mail sales@arcadiapublishing.com
For customer service and orders:
Toll-Free 1-888-313-2665

Visit us on the Internet at www.arcadiapublishing.com

To the residents of Maple Shade, New Jersey.

Contents

Acknowledgments		6
Introduction		7
1.	Pioneers	9
2.	The Village	25
3.	Suburban Town	45
4.	Churches	71
5.	Schools	81
6.	Police and Fire Departments	93
7.	Main Street and Stores	103
8.	Business and Industry	111
9.	Notables	123

ACKNOWLEDGMENTS

The Maple Shade Historical Society would like to thank all the citizens and friends of Maple Shade for sharing their time, photographs, and memories. We especially thank Elizabeth Procopio, Joseph Dugan, Karen Mennel Pike, Richard Rowan, Frank Brooks, and Frank Kozempel for helping in the production of this book.

We would like to thank the following people whose photographs captured a time in our town's past: Hank Baron, Rose Bell, Craig Bennett, Katherine Black, John Brasko, Frank Brooks, Hank Cavallo, Robin Cucinotta, Joseph Dugan, Dottie Falkenstein, the Gaul family, Mike Geden, Dot Johnson, Dorothy Klamer, Frank Kozempel, Joe Peditto, Karen Mennel Pike, Elizabeth Procopio, Joanne Ratzell, Leon Santore, Richard Rowan, Emma Sheppard, Meta Taby, Rita Grabovich, Elesnor Schmidt, Joseph Gudonis. A special thanks goes to Anna Stiles Sharp and family for donating a large collection of photographs taken in 1897 by George Decou of Maple Shade.

INTRODUCTION

The Maple Shade Historical Society has endeavored to provide a glimpse into our town's past. It was Arthur N. Cutler, the first president of the historical society, who acquired the Little Red Schoolhouse (Chesterford School) from the township in 1956. The one-room schoolhouse is now a museum and it is the headquarters of the historical society. Charles Cutler became the second president. Edith Cutler used her gathered information to write the book *Maple Shade—A Story of Three Hundred Years* in 1982. She passed away in 2000 at age 95. Ellen Shiplee became the third president of the historical society in 1965. She and Horace Shiplee provided tours and information of the society until they retired. They both passed away in 2007. We will miss our members and friends who have recently passed away and who provided help with this book. Especially Frank Brooks, whose mother, Rachel McElwee, and aunts attended the one-room schoolhouse, and Hank Cavello, who provided sports photographs. As its fourth president, it is my hope that the Maple Shade Historical Society will grow and benefit from this book. It is also hoped that an awareness and appreciation of the history of Maple Shade will be shared and enjoyed.

—Betty Procopio

One

PIONEERS

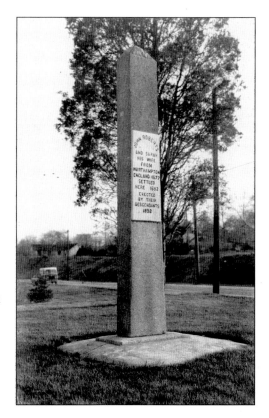

The Roberts Monument was erected by the Roberts family and unveiled on November 14, 1898, on John and Margaret Mason's farm in the presence of about 100 descendants. The descendants' names at the gathering included Roberts, Matlack, Lippincott, and Haines. Today the area is on East Main Street between the Route 73 ramps. It serves to mark the location of Mason family ancestors John and Sarah Roberts's first home, a cave dugout. The monument is a granite shaft bearing the inscription, "John Roberts and Sarah, his wife, from Northamptonshire, England, 1677; settled here 1682; erected by descendants 1898." (Courtesy Arthur Cutler.)

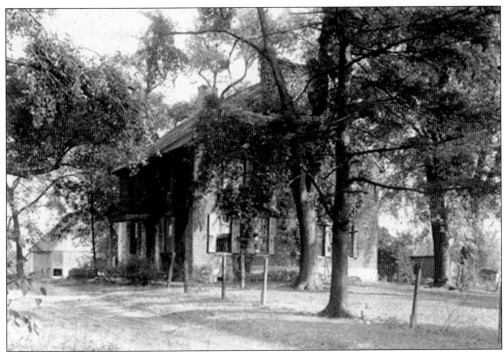

The John and Mary Roberts house once stood on Fellowship Road between Route 73 and Main Street. The house was built in 1736. (Courtesy Nathaniel R. Ewan.)

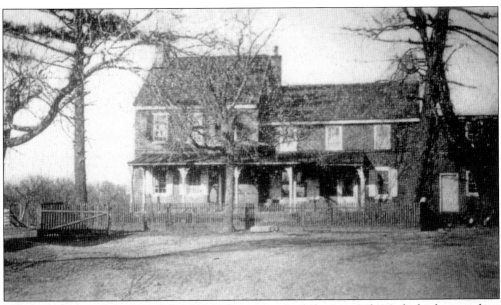

The central part of the Jeremiah Matlack house was built by Jeremiah Matlack, the grandson of the pioneer William Matack, in about 1753. It was built on the same spot where William's original homestead once stood. The last owner of the house while it was still a farm was Charles C. Haines. It then became the clubhouse for the Valley Brook and then Spring Hill Country Club golf courses. It was razed around 1971 for the building of Spring Hill apartments, now Fox Meadows apartments. (Courtesy Maple Shade Historical Society.)

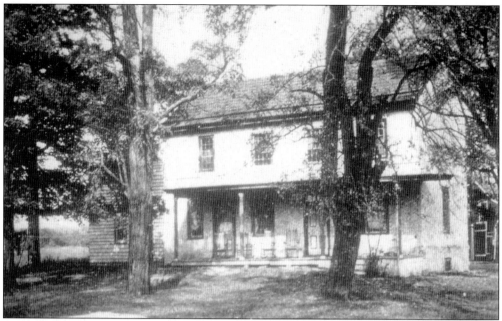
The William Matlack III house was built by another grandson of William, the pioneer. The accepted date of its construction is 1751. Later it was the George Matlack home. It is now on Dead End Lane. (Courtesy Maple Shade Historical Society.)

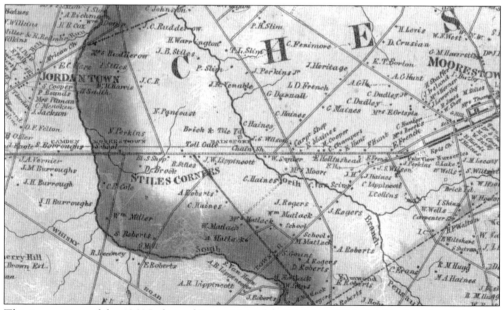
This is a section of the 1860 Lake and Beers *Map of the Vicinity of Philadelphia* that shows the area of Stiles Corners (present day Maple Shade). Many people believe that the railroad first brought identity to the area. This map also shows the brick and tile yard. (Courtesy Paul W. Schopp.)

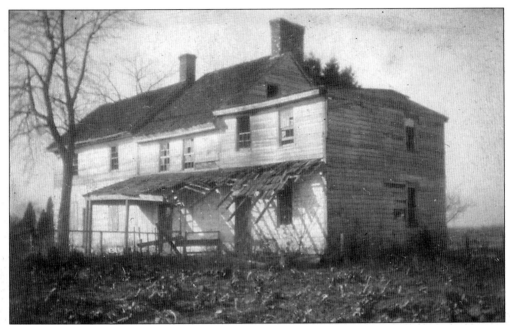

Benjamin Stiles grew up in and later inherited the "Old Place of the Stiles," which was located at the northernmost end of Stiles Avenue. He left the home to live at the junction of the Moorestown and Camden Turnpike and the Fellowship Turnpike Road as he was a proud part of the turnpike's start there. The location of the home is about where either pioneer Robert Stiles or his son Robert, also a pioneer, originally settled. (Courtesy Maple Shade Historical Society; photograph by George DeCou.)

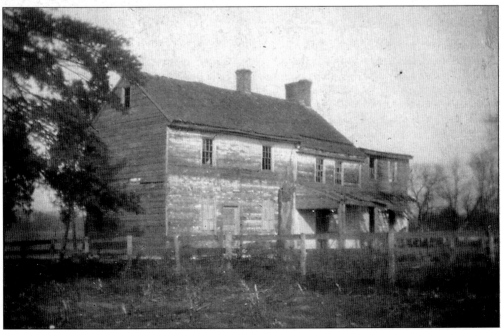

Shown here is a southeast view of the Benjamin Stiles house. (Courtesy Maple Shade Historical Society; photograph by George DeCou.)

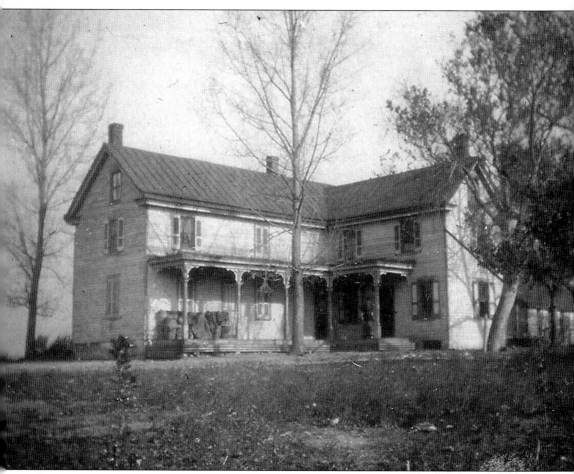

Isaac Stiles was the oldest son of Benjamin Stiles. Benjamin bought this house for Isaac and his bride, Eleanor, from Samuel Burrough, who most likely built it in 1773. After Isaac, John S. Collins bought it for the Collins' Orchards farm, which was continued by his son Lester Collins. The business went under during the depression, and the house was divided to make two tenant farm homes, half of which was moved across the street. An apple orchard farm still remained for years with the main house. The half that was moved was first owned by Ezra Olt, and then the Santore family bought it for a horse farm. The Olts and Santores owned racehorses together and went by the stable name of S.O.S. Racing Santore-Olt-Santore. Both halves of the house are still located on Collins Lane. (Courtesy Maple Shade Historical Society; photograph by George DeCou.)

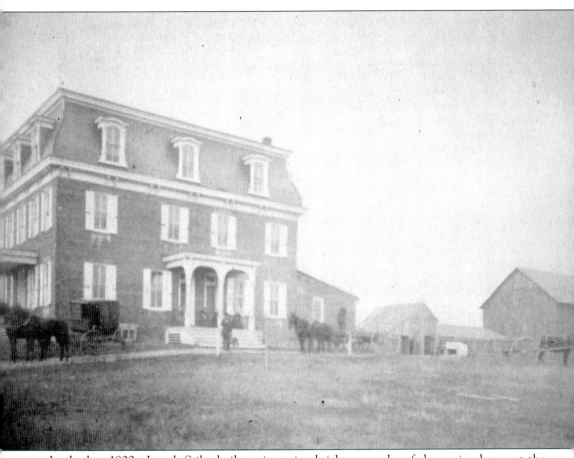

In the late 1800s, Joseph Stiles built an imposing brick mansard-roofed mansion house at the corner of Linwood and Stiles Avenues. The house was sold by Joseph's son Benjamin in 1912 to Horace Roberts, a real estate developer. The huge mansion found its use as a factory building for a silk mill. It was razed by the early 1940s and the modern factory building was enlarged. The factory made hosiery when it was the E. W. Twitchell Company and woman's coats when it was owned by Warick Fashions. In the early 1990s, the factory was renovated into the new Maple Shade Municipal Complex. (Courtesy Maple Shade Historical Society.)

Benjamin J. Stiles was the youngest son of Benjamin Stiles. Thomas Wilson was Benjamin's father-in-law and guardian of his infant son. When Benjamin J. Stiles died, Thomas Wilson, who lived on what is now Mecray Lane in the Maple Shade farmhouse, sold Benjamin's farm and his own. This is an advertisement from the *New Jersey Mirror* newspaper from September 10, 1873, for the sale of the house.

GUARDIAN'S SALE

In pursuance of an order of the Court of Chancery of the State of New Jersey, made on the 30th day of July, 1873, in the matter of the application on behalf of Thomas W. Stiles, an infant, for the sale of lands, I will sell at public vendue, on

Saturday, October 11, 1873,

Between the hours of 12 and 5 o'clock in the afternoon of said day, (sale to commence at 2 o'clock, P. M.,) on the premises, all that certain

FARM OF ONE HUNDRED ACRES,

late the property of Benjamin J. Stiles, deceased, situate on the turnpike road, from Moorestown to Camden, about 2¼ miles from Moorestown, and about a quarter of a mile from Stiles' Station on the C. & B. Co. Railroad; about 80 acres of said land, with the buildings, is situate on the southerly side of the turnpike road. The buildings consist of a Two-story Frame Dwelling House, with good water in the kitchen, barn, crib-house, and other out-buildings, in good repair and nearly new. There are on the property, about 100 Apple and other fruit trees, in the prime of bearing.

About 20 acres of said farm are situated on the north side of the turnpike road, and in front of the buildings, adjoining lands of said Railroad Co. and of J. B. Stiles and others.

This property is well adapted to building or farming purposes; is of first quality, and will be sold altogether, or in parcels, as may best suit purchasers. Conditions made known on the day of sale, by the subscriber.

THOMAS WILSON,
Sept. 10, 1873. Guardian.

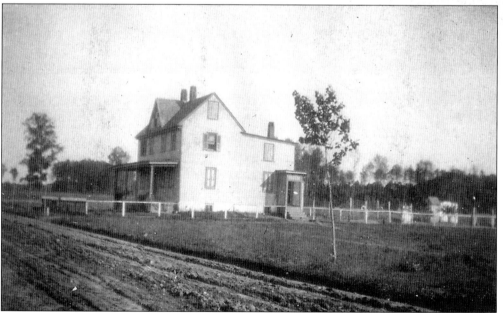

The Benjamin J. Stiles house is seen here at 70 South Poplar Avenue, where it was moved to and altered somewhat from its original structure. It was moved to become a home on the Shuster Tract in the "newly planned village of Maple Shade." It once stood at the present location of Our Lady of Perpetual Help School. (Courtesy Maple Shade Historical Society; photograph by George DeCou.)

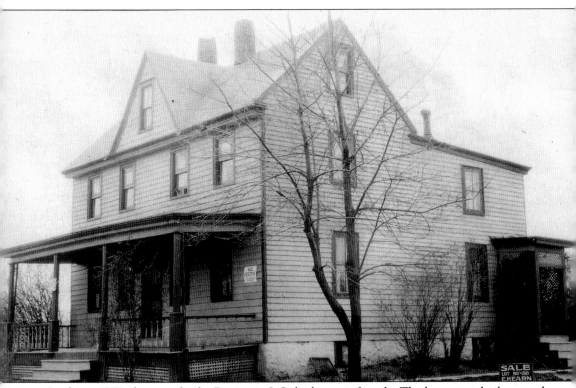

In this c. 1900 photograph, the Benjamin J. Stiles house is for sale. The house was built around 1849. When Benjamin J. Stiles died at a young age, his father-in-law Thomas Wilson moved. Wilson owned the old Isaac Stiles house, later known as the Maple Shade farmhouse, and was the guardian of Benjamin J. With a lack of Stiles families now in the area, Stiles railroad station was renamed Maple Shade in 1874. (Courtesy Maple Shade Historical Society.)

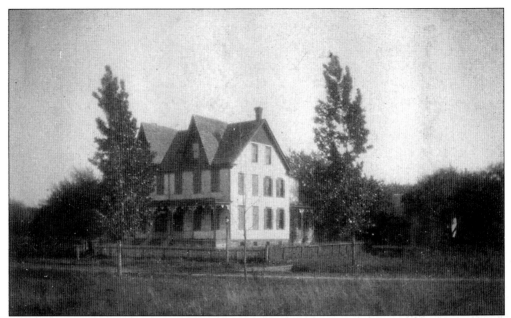

This large double house once stood on Poplar Avenue, just off of Main Street. This is where Joseph B. Stiles lived when he retired from farming. It was later rented by the Mennel family and used as the post office until they bought their house and store on Main Street. This house burned down in the early 1900s. (Courtesy Maple Shade Historical Society; photograph by George DeCou.)

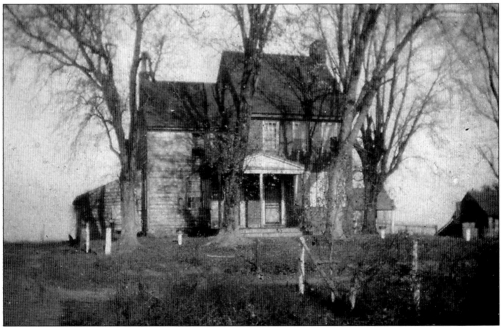

Jacob W. Stiles lived a short distance from the iron bridge at the turnpike in the village of Fellowship. He was a son of Isaac Stiles, who lived in the house on Collins Lane. His real first name might have been Israel, not Jacob, as indicated in a census. (Courtesy Maple Shade Historical Society; photograph by George DeCou.)

The 1742 Thomas Cowperthwaite house still stands today at the northeast corner of Kings Highway and Lenola Road in Moorestown, just over the border from Maple Shade. The Cowperthwaite land extended from Moorestown to Maple Shade and included the land at

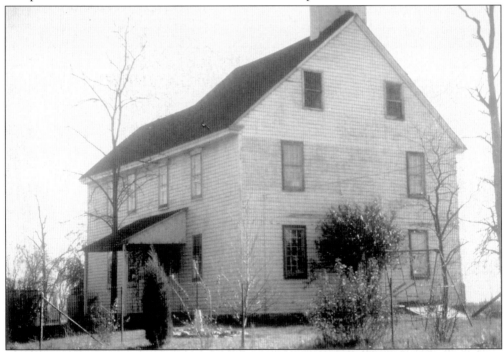

The Charles Buzby house, built about 1862, was located on Schoolhouse Lane, just east of Route 73. (Courtesy Maple Shade Historical Society.)

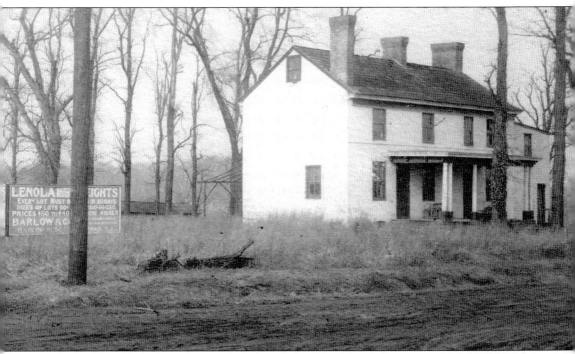

Schoolhouse Lane where the Chester Brick Schoolhouse once stood. A sign on the property reads "Lenola Heights . . . Barlow and Company."(Courtesy Maple Shade Historical Society.)

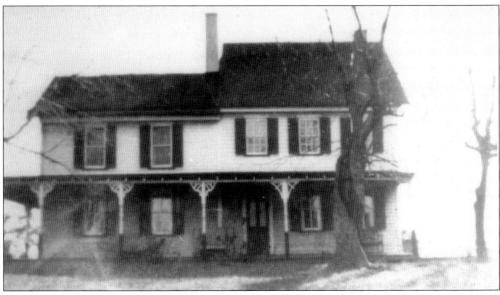

The John S. Rudderow house was located on Park Avenue, near the Pennsauken Creek and Rudderow's Bridge, which was located where Park Avenue crossed the creek. John Rudderow was the second-oldest son of Samuel Rudderow and bought the farm from him. Perhaps this home might have belonged to both men. Later it was the Hoehn farm. The last owner is said to be Herbert Holmes. The land is now a part of the Park Estates development. (Courtesy Maple Shade Historical Society.)

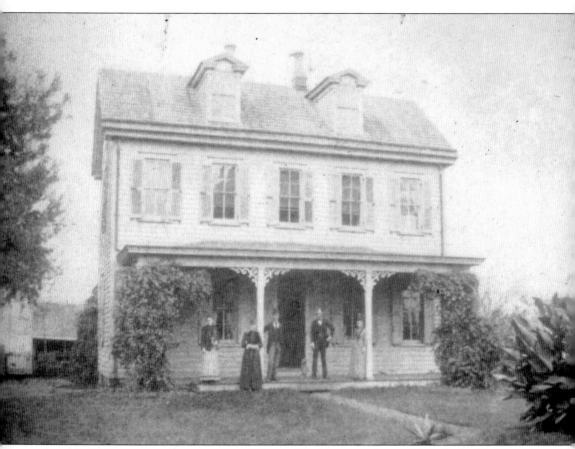

Isaac F. Rudderow was the oldest son of Samuel Rudderow and most likely built this home in 1867, as a deed indicates. It was later the Thomas and Josephine Beideman farm, the Samuel Wagner farm, a part of Lester Collins's orchards, the Thomas and Grace Henkels farm, and the Ralph and Alice Gale florists' property that contained greenhouses where the Howard Yocum school now stands. It was razed in 1974 for the Pinewood Acres Nursing and Convalescent Center, which is now called Sterling Manor. (Courtesy Maple Shade Historical Society.)

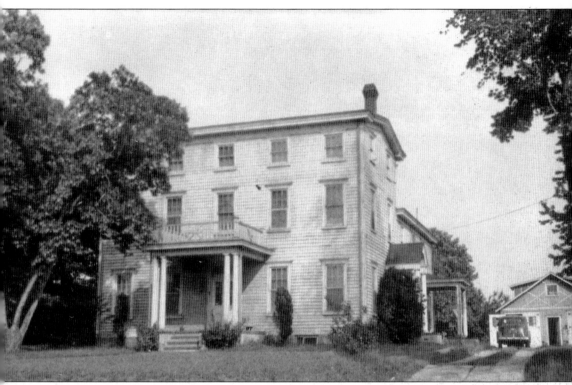

This house was built in the Italianate style at 14 West Mill Road near the Mill Road School. Either Levi B. Stiles or Samuel Roberts built it; however, maps indicate that it was most likely Roberts between 1860 and 1876. Alfred Rudderow was a son of Isaac F. Rudderow and bought it in 1904 from the Roberts family. The Rudderow farm contained over 124 acres, and South Forklanding Road stopped at Mill Road in front of it until decades later when the road was extended. The house was razed around 2001 for the expansion of a school parking lot. Rudderow Avenue is a nearby street, which got its name from the real estate developer George Martin as he developed the former farmhouse land. The garage in this photograph was built from an old barn by builder John E. Otto. (Courtesy Maple Shade Historical Society.)

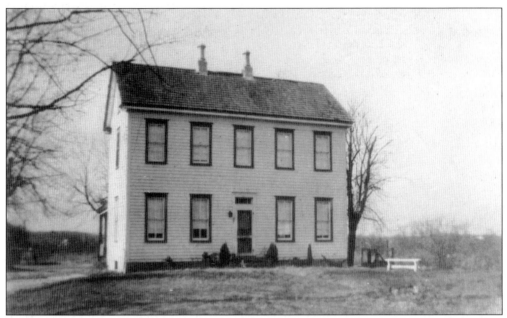

This is a later photograph of the Isaac F. Rudderow house taken by Arthur Cutler in the late 1950s or early 1960s. It was located at 774 North Forklanding Road and was one of the first homes built on that road. A noteworthy fact of the house is that it was built to last. Its foundation was 18 inches thick, and it had six-by-six-inch cellar beams. Here the home has been somewhat modernized in its appearance. (Courtesy Maple Shade Historical Society)

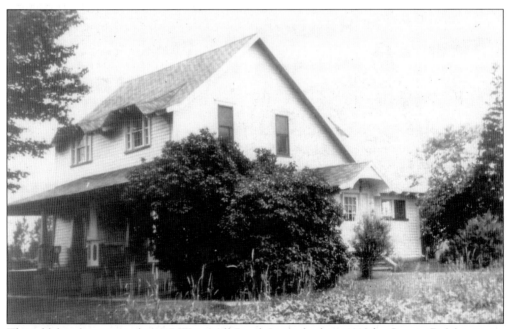

This old farmhouse stood at 317 West Mill Road. It was built in 1913 by George D. Martin out of an old farmhouse that burnt down in 1912. A wagon shed and corncrib were moved over the foundation and remodeled into this eight-room dwelling. This was probably Samuel Roberts's old farmhouse. (Courtesy Cutlers Family.)

The July 16, 1862, *New Jersey Mirror* newspaper includes an advertisement for the sale of the Josiah C. Rudderow farm. It was off North Forklanding Road on the east side near Cinnaminson. The land was later owned by the Slim family.

VALUABLE FARM

In Chester Township, Burlington County,
AT PRIVATE SALE.

In consequence of failing health, the subscriber will sell, at private sale, his FARM, situated in the County and Township aforesaid, 7 miles from Camden and 3 from Moorestown, and fronting on the public road leading from the Turnpike to the Landing at the head of navigation on Pennshawkin creek. The FARM

Contains 148 Acres!

20 acres of which are Woodland, and 18 Meadow; the balance, with the exception of about 20 acres of light soil, is well adapted to Grain and Grass, and is divided by good Cedar Fencing, into convenient sized fields. The Improvements consist of a substantial Two-Story FRAME DWELLING HOUSE, containing 12 rooms, and Kitchen attached; 2 large Barns, with cattle Stabling and Wagon Sheds adjoining; large two-story Carriage and Corn House, with Cellar below, and ample Granaries above; Milk House over a cold and never failing Spring. Also, Meat House, Wood Shed, &c., convenient to dwelling. There are on the Farm, 9 acres of Apple Orchard, in prime bearing order, with a variety of other Fruit.

The Land is in a good state of cultivation, and well worthy the examination of any one desiring a good Farm. Terms Easy. For further information call on the subscriber, residing thereon.
JOSIAH C. RUDDEROW.
July 16, 1862.

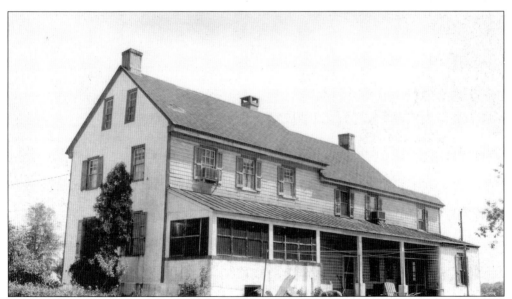

Peter H. Slim owned this house, and 1876 and 1877 atlas maps indicate that his relation Samuel Slim also lived here. It was probably the Josiah C. Rudderow house previously. Frederick Hintermeier owned the house after the Slims, then Abraham and Mollie Wax, Horace Roberts, and Adolf and Pauline Veser, respectively. The last owner of the house was Alfred C. Brooks. It was located at 234 High Street on the corner of Route 73 and High Street. It was razed for a Bi-Lo gas station in 1970. (Courtesy Maple Shade Historical Society.)

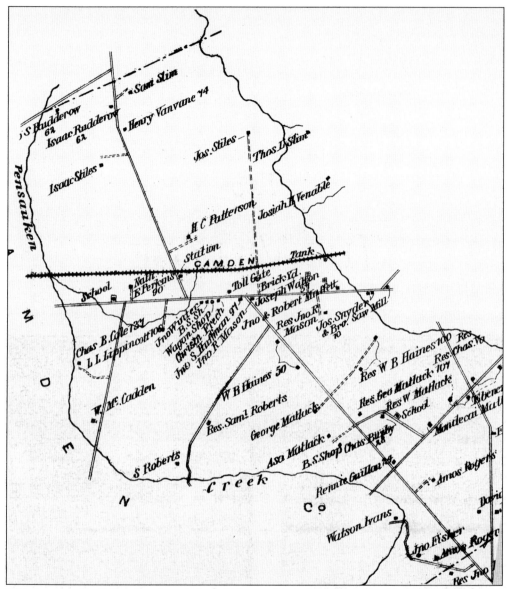

This is a map detail showing the portion of Chester Township that is now Maple Shade from the Combination Atlas Map of Burlington County, which was first published in 1876 by J. D. Scott. The 1876 atlas was reprinted by the Pemberton Historic Trust.

Two
THE VILLAGE

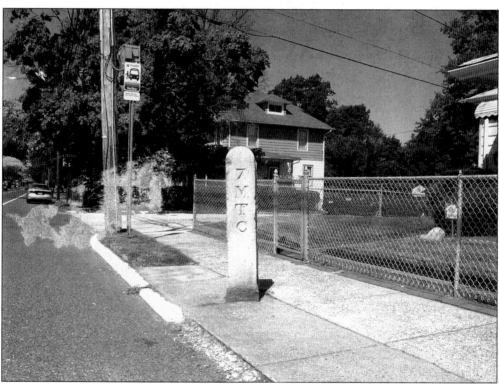

This is a mile stone that is located at Main Street and North Holly Avenue. It was placed there about 1849 or 1850 by the Moorestown and Camden Turnpike Company. Another mile stone is located near the bridge on the south branch of the Pennsauken Creek going into Cherry Hill township. On one side, it is marked seven miles to Camden and on the other side, two miles to Moorestown. (Courtesy Maple Shade Historical Society.)

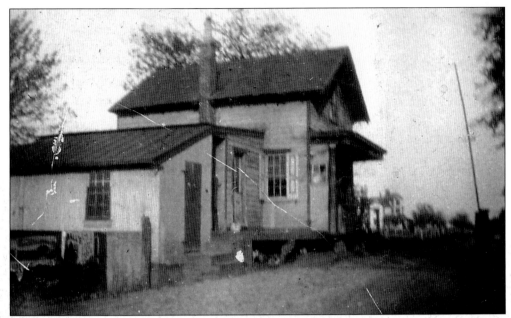

This is the Moorestown and Camden Turnpike tollhouse and pike that was located near Fellowship Road, which was also a turnpike. It was built about 1849 or 1850. This view is looking east toward Moorestown and the Charles Zane farm can be seen in the background. (Courtesy Maple Shade Historical Society; photograph by George DeCou.)

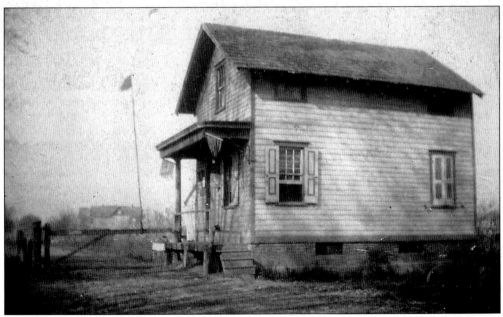

Looking west toward Camden, this is another view of the Moorestown and Camden Turnpike tollhouse and pike (gate). Henry Fahr's house is in the distance on the right. A toll gate tender who lived here, according to the 1860 census, was Benjamin Welcher (or Wiltshire) with his wife, Elizabeth, and daughter Hetty. (Courtesy Maple Shade Historical Society; photograph by George DeCou.)

This is an 1897 photograph of Main Street, the area between Poplar and Maple Avenues. The backs of Henry Fahr's house and general store and Adolf Klinger's brick house and shoe store can be seen. On the other side of the road is Christian Frech's old "wagon builder" building that was later moved to Spruce Avenue. Some of these houses are still there today mostly hidden by their storefront additions. (Courtesy Maple Shade Historical Society; photograph by George DeCou.)

Nathan Perkins was related to the Perkins family of Moorestown who ran the Fairview Nurseries. In 1849, he moved into the house seen here, which was bought for him by his father whom he paid back later. He planted evergreen trees in the yard and named the farm Evergreen Terrace. Perkins had orchards and crops on his farm, but his interests were in real estate, and he traveled the country doing business in that field and left the farm for his sons to tend. He wrote a book about his real estate journeys and his Civil War aide experiences titled the *Events and Travels of Nathan E. Perkins*, which was published 1877. This is a picture of the farm as seen in his book. (Courtesy Free Library of Philadelphia and the Historical Society of Pennsylvania.)

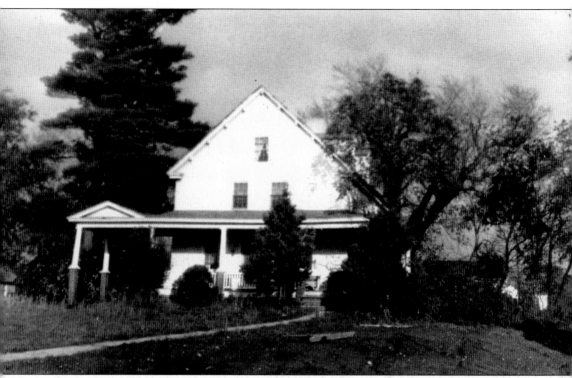

This is a photograph of the Perkins farmhouse after it became a part of Horace Robert's development of bungalow homes. The side is now the front of the house and is located at 31 North Coles Avenue. According to Perkins's book, the house originally had a red roof, as he wrote that it was nice returning to his home with a red roof. (Courtesy Maple Shade Historical Society.)

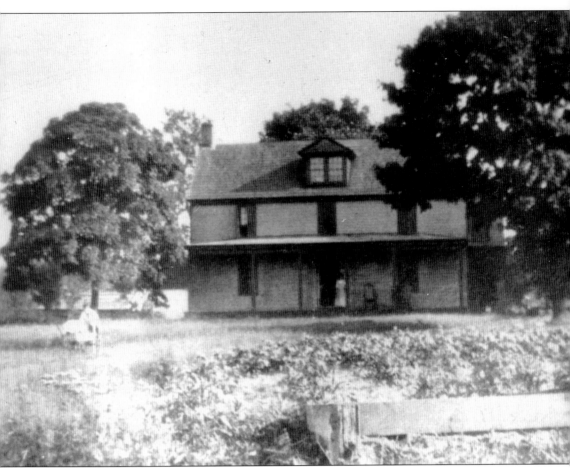

The Levi Lippincott farmhouse still stands today, in part, though it was moved and rotated by Fred Fister to form a home on South Lippincott Avenue. A portion of the house sits on the original foundation and at the same angle it always did. Lippincott bought the land, and presumably the farmhouse, in 1871 from John Needles Jr. Shortly after buying the farm, Lippincott sold land to Christian Frech and John Winter. South Lippincott Avenue was once a lane that led to Lippincott's house, which had a large barn to the west of it. A small creek once branched to the front and back of the house and the hill between was an ideal spot for an early plantation home. (Photograph by Mrs. Bert Edgar.)

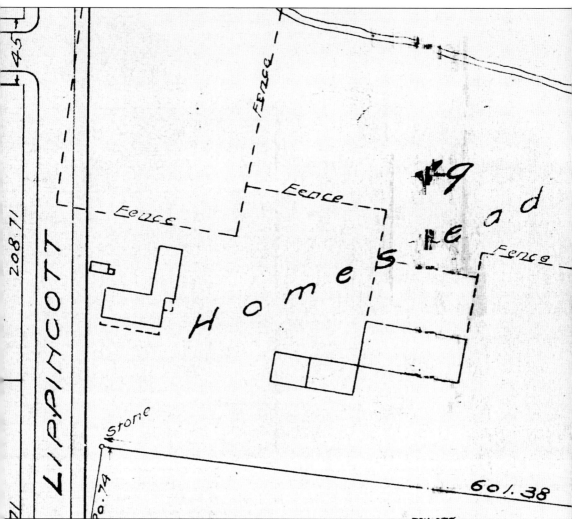

This detail is from the Plan of the Orchards. In 1912, Camden attorney John F. Harned bought the Lippincott farm from Henry T. and Emma E. Bleam. In 1914, the Plan for the Orchards shows that the houses were to be built on one-acre farm lots by Barlow and Company. The farmhouse was kept on a larger lot and called the Homestead on the plan. With the name orchards, one can imagine what the Bleams had on the farm. (Courtesy Burlington County Clerk's office.)

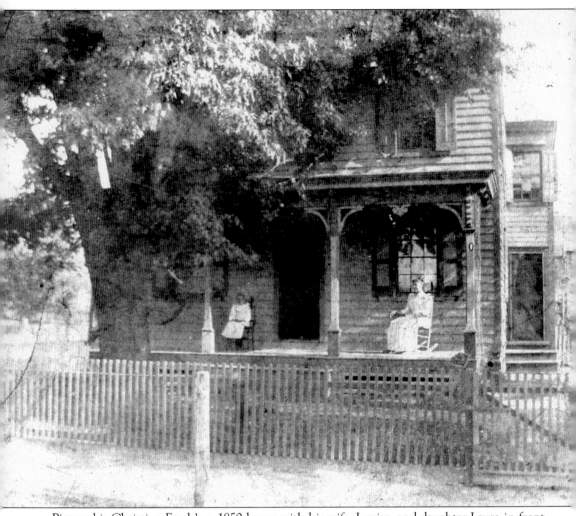

Pictured is Christian Frech's c. 1850 house with his wife, Louisa, and daughter Laura in front. Frech originally worked as a blacksmith alongside wheelwright John Winter. In a 1916 *Maple Shade Progress* newspaper story, Louisa tells of how the houses along the Moorestown and Camden Turnpike (Main Street) had only two shops. Christian Frech's house, at 110 East Main Street, was razed in 1966 and a bank was built on the site two years later. (Courtesy Karen Mennel Pike.)

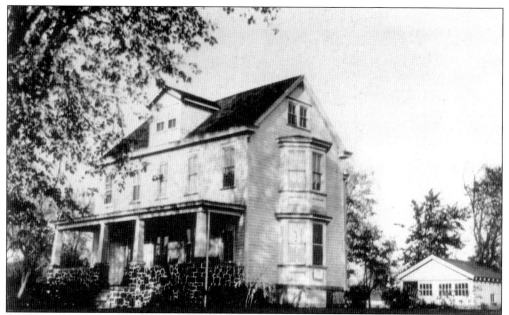

Elam Brubaker moved to Maple Shade in 1883 and had this house built. It was one of the first homes on the north side of the Moorestown and Camden Turnpike. The house was located at the end of a lane between what is now North Lippincott Avenue and North Forklanding Road. It was moved by builder John E. Otto to face North Lippincott Avenue. Later Acme bought it and razed it for a parking lot. (Courtesy Maple Shade Historical Society.)

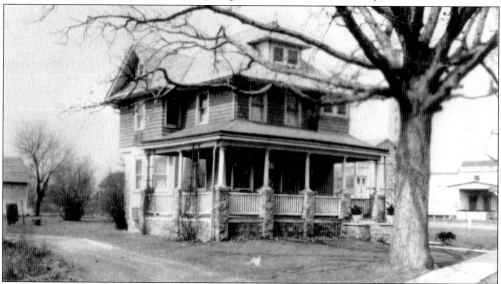

This is the Jesse Brubaker house. It is now a funeral home at the corner of North Forklanding Road and Brubaker Avenue. Jesse was the son of Elam Brubaker. The Brubakers moved to town in 1883 and had a uniform factory in Philadelphia at the time. Elam moved the factory to Maple Shade in the 1920s, and it was carried on by his son and grandsons. Jesse and his family moved into this home on North Forklanding Road in 1911. He and his sons Jesse Jr. and Norman continued Elam's uniform factory under the name of J. Brubaker and Sons. (Courtesy Maple Shade Historical Society.)

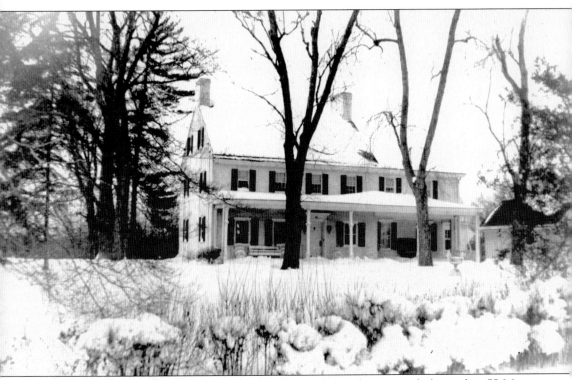

This plantation home was built by Isaac Stiles in 1769 and is presently located at 55 Mecray Lane. Henry C. Patterson later lived there, and it is said that he is responsible for the town's name of Maple Shade because he planted maple trees down his lane and near the railroad station and called his farm the Maple Shade farm. (Courtesy Frank Kozempel.)

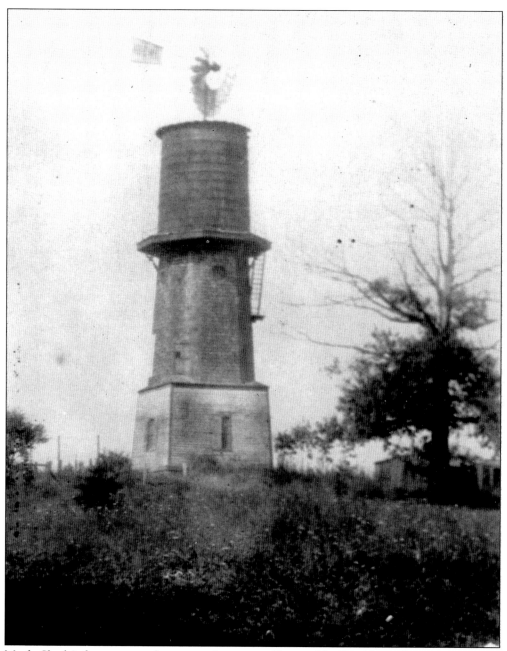

Maple Shade's first waterworks was an Artesian well owned by Dr. Alexander M. Mecray and was located on West Park Avenue. It was built in 1893 by contractor Uriah White for Mecray. Its depth was 375 feet with boulder gravel at its base and an elevation of 55 feet. The well supplied quality water to his house and about seven nearby homes.

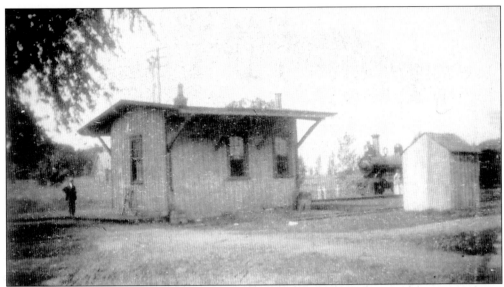

This 1897 photograph is the earliest known photograph of the Maple Shade train station at North Forklanding Road. Contrary to many newspaper and historian accounts, the train station was never moved from Stiles Avenue. It was always located at North Forklanding Road, although it was only a platform until the 1870s. By June 1874, most Stiles family members no longer lived in the area, so the railroad company renamed Stiles Station as Maple Shade Station. (Courtesy Maple Shade Historical Society; photograph by George DeCou.)

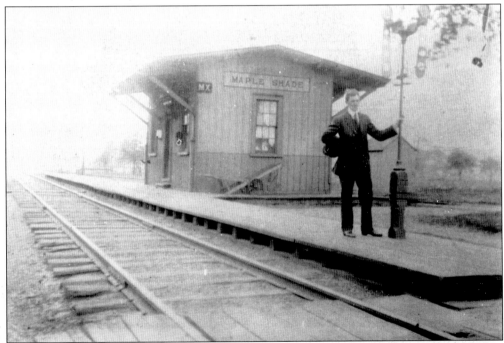

This is a train station photograph taken in 1905. Pictured is station agent Harry E. Gilbert. The train's engineer was Robert Stuart from Camden. The former station agent was William J. Broadwater. (Courtesy Maple Shade Historical Society.)

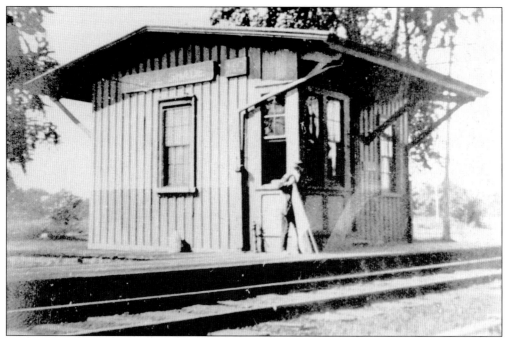

This photograph, taken in the early 1900s, is the first to show the alcove window that remains on the railroad station today. Several additions were built on the station by the mid-1920s. (Courtesy Maple Shade Historical Society.)

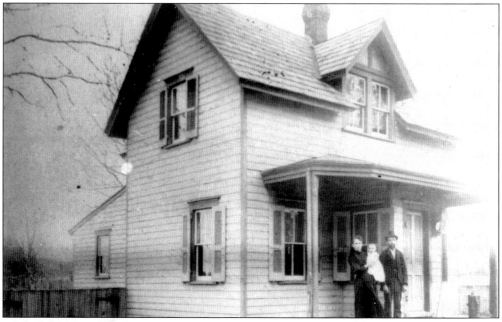

A second tollhouse and tollgate was added in 1880 to the southeast corner of Main Street and Coles Avenue because people would bypass the Fellowship Road tollgate by traveling along the road by the railroad, which is now called Front Street. Both tollgates were discontinued in 1909. Tollgate tender Charles McElwee is pictured with his wife and daughter Rachel. (Courtesy Maple Shade Historical Society.)

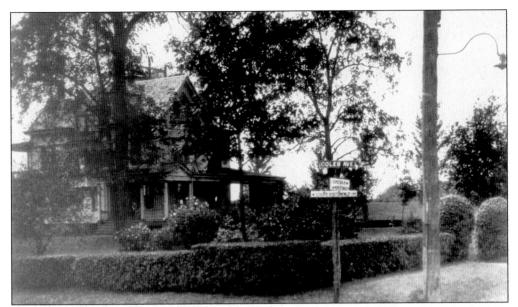

The Henry B. Coles mansion was located at the southwest corner of Main Street and Coles Avenue. His father, Charles B. Coles, owned the C. B. Coles and Sons Lumber Company in Camden and the Alden Park–area land. The Sharpless family then owned the house and the property was known as Hillcrest farm. The house was later destroyed by a fire. Ezra Olt then had a farm and lived in a large brick house on the property. That house is still there today, behind what was a gas station. (Courtesy Maple Shade Historical Society.)

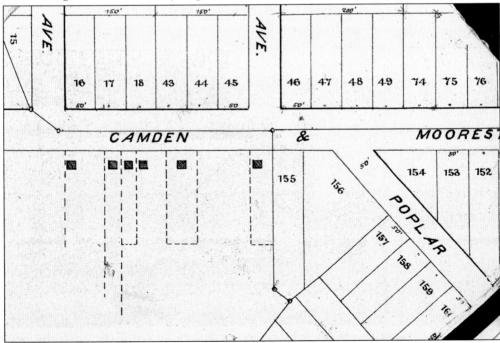

In 1887, Charles F. Shuster made the town's first subdivision of Maple Shade, which was known as the Shuster Tract and built on land formerly part of Benjamin J. Stiles's farm. (Courtesy Burlington County Clerk's office.)

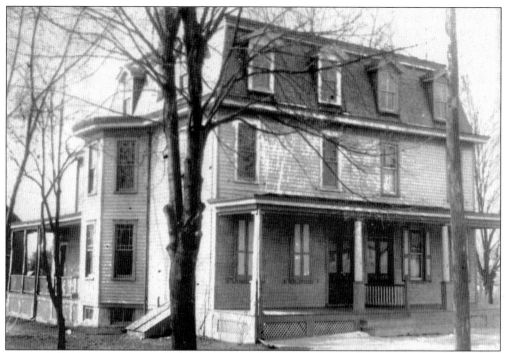

This double house was built about 1889 and is located at 50–52 South Fellowship Road. In 1905, it was purchased and occupied by Samuel and Sarah Larzalere who had four girls and two boys. (Courtesy Maple Shade Historical Society.)

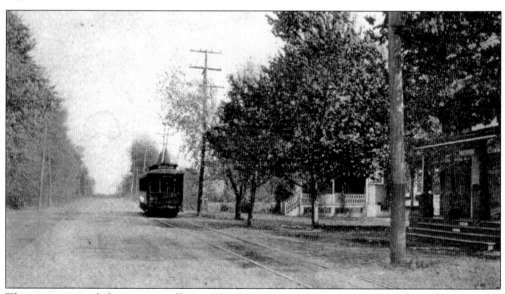

This is a postcard showing a trolley at Main Street at Spruce Avenue. To the right, the John Mennel Dry Good Store and Post Office can be seen. The formal opening of the Burlington County Traction Company's trolley line from Camden to Mount Holly occurred on May 5, 1904. (Courtesy Dennis Weaver.)

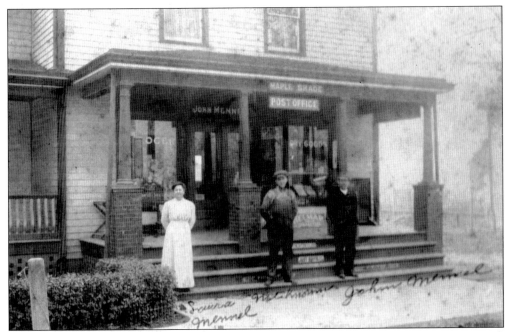

The John Mennel Dry Good Store and Post Office was located at 116 East Main Street. Pictured, from left to right, are Laura Mennel, an unidentified person, and John Mennel. John and Laura owned Mennel's Dry Goods Store, which was the location of the Maple Shade Post Office from about 1909 to 1926. (Courtesy Mennel family.)

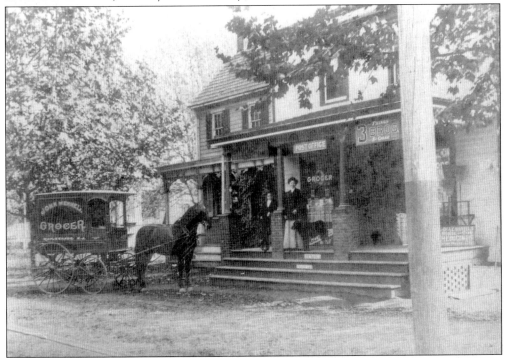

This is a photograph of John Mennel Dry Good Store and Post Office with a horse and wagon. Richard Harbaugh, Louisa Mennel, and a dog are on the porch. (Courtesy Mennel family.)

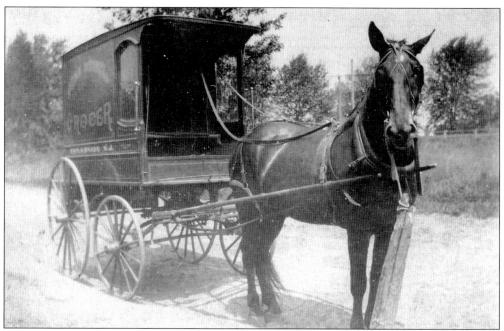

Seen here is the Mennel grocer wagon. The Mennel, Fahr, and Childs stores all had a home delivery service. A boy went by bicycle on Fridays to customer's homes to take grocery orders for Saturday deliveries. On Saturdays, the orders were delivered by horse and wagon. (Courtesy Mennel family.)

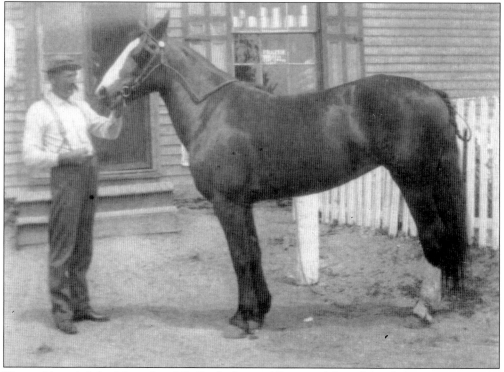

Pictured here is John Mennel and Dolly the horse. (Courtesy Mennel family.)

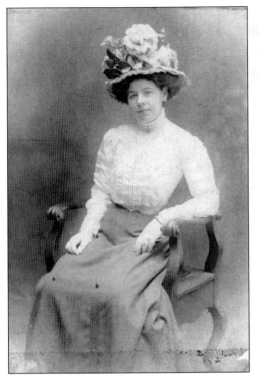 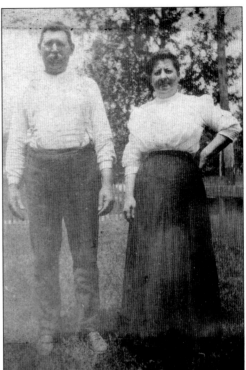

On the left is a 1910 photograph of Louisa Mennel, Laura Mennel's daughter. Louisa took over as postmistress after her mother passed away. On the right is a 1920 photograph of John and Laura Mennel. (Courtesy Mennel family.)

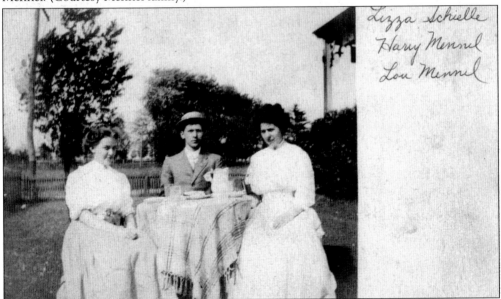

Pictured from left to right, having a picnic at Christian Frech's house, are Frech's grandchildren Lizza Schielle, Harry Mennel Sr., and Louisa Mennel. Many postcards were not published cards, but the Mennel family had photographs developed this way to mail to their relatives. (Courtesy Mennel family.)

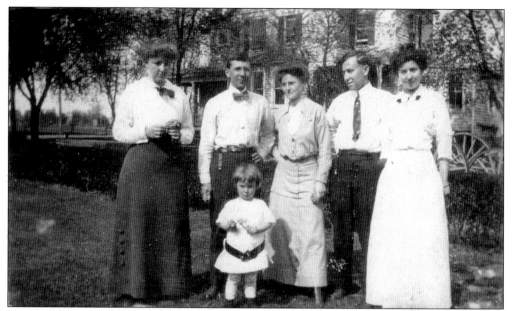

Pictured, left to right, are Nellie Farrow, Harry Mennel Sr., Elsie Saal, Jack Saal, and Louisa Mennel with Irene Saal in front. In the background is Frech's house with a wagon on Spruce Avenue. (Courtesy Mennel family.)

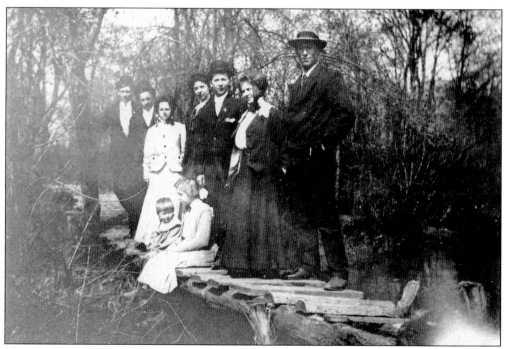

This is a family postcard from the Mennel family. Harry Mennel Sr. and family took a Sunday afternoon trip to the Pennsauken Creek in the early 1900s. On the back of the postcard it says, "Hope to see you here next Sunday." (Courtesy Mennel family.)

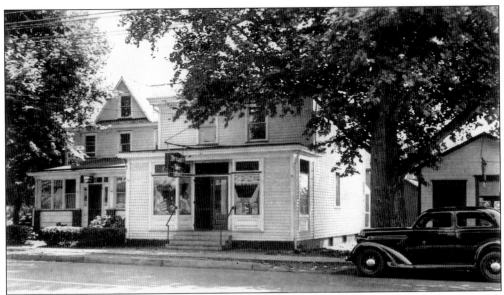

This 1938 photograph shows Mennel's Inn, located at Main Street and Spruce Avenue. The Mennel's home was next door. Harry B. Mennel Sr. made Mennel's a bar and inn and operated it with his sister Louisa Mennel, who was known as Aunt Lou. Harry B. Mennel Jr. took over the business from them. It was later called the Red Carpet Lounge and now is a Charlie Brown's restaurant. (Courtesy Mennel family.)

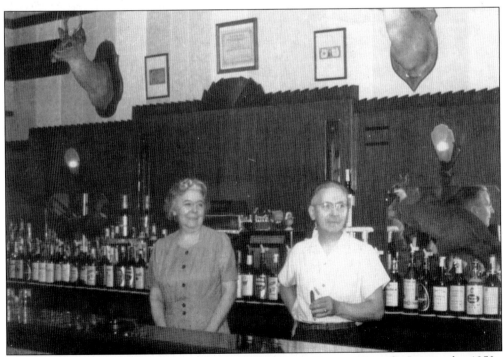

Louisa and Harry B. Mennel Sr. are shown here bartending at Mennel's Inn in the 1950s. (Courtesy Mennel family.)

Three
SUBURBAN TOWN

The 1887 Charles F. Shuster plan and the 1890 Maple Shade Land and Improvement Company plan did not bring many people into town. It remained a rural village on the train route. The post–World War I housing demand and then the coming of automobiles and bridges later brought blue-collar development-type homes (bungalows at first) and a suburban complexion to the town. (Courtesy Paul W. Schopp.)

For Gilt Edge Investments buy "Outside Philadelphia" Property

Land Purchases—The Best Money Multiplier.

MAPLE SHADE

A Veritable Garden Spot.
(The Bryn Mawr of New Jersey.)

The most beautiful and healthful suburban village within easy access of Philadelphia.

On the PENNSYLVANIA RAILROAD.
(Mount Holly Division.)

6¼ miles from **MARKET ST. FERRY.**
13 minutes' ride from
7 cents commutation fare from

34 Trains Daily.
Post Office on the grounds.

Bond Investments, Mortgages and Building Associations are all good, but money invested at once in

BUILDING SITES AT

MAPLE SHADE

will yield 200 per cent. profit in much shorter time.

SIZE OF LOTS, 50 X 150.

Pennsylvania Railroad Depot on the Grounds.

45 Magnificent Home Sites fronting on the Railroad, with a 100 feet Boulevard. No Lot in the plant more than 2 blocks from the Railroad Depot. Avenues 60 feet wide. Magnificent Shade Trees of Maple. MAPLE SHADE already an established fact. Population about 200.

A limited number of these beautiful Home Sites For Sale. Terms to suit purchasers.

For Illustrated Map, Descriptive Circulars and full particulars, apply to

The Maple Shade Land and Improvement Co.

NO. 11 SOUTH NINTH STREET, PHILADELPHIA. (2D FLOOR, FRONT ROOM.)

CLARENCE D. ANTRIM, VICE-PRESIDENT.

This is a Maple Shade Land and Improvement Company advertisement from the *Season of 1890–1891 Philadelphia Lyceum Bureau Programme*, published by Clarence D. Antrim. The group, made up mostly of Philadelphia businessmen, purchased land north of the railroad extending to Park Avenue and west from Fellowship Road to Coles Avenue for a plan of house building lots. The Maple Shade Land and Improvement Company consisted of John C. McAllister as president, Clarence D. Antrim as vice president, Theodore R. Kellner as secretary, Edgar Vanderslice, James White, Charles P. Trittle, and Alexander M. Mecray. It was incorporated on December 10, 1891, and filed for dissolution on March 3, 1897. (Courtesy Maple Shade Historical Society.)

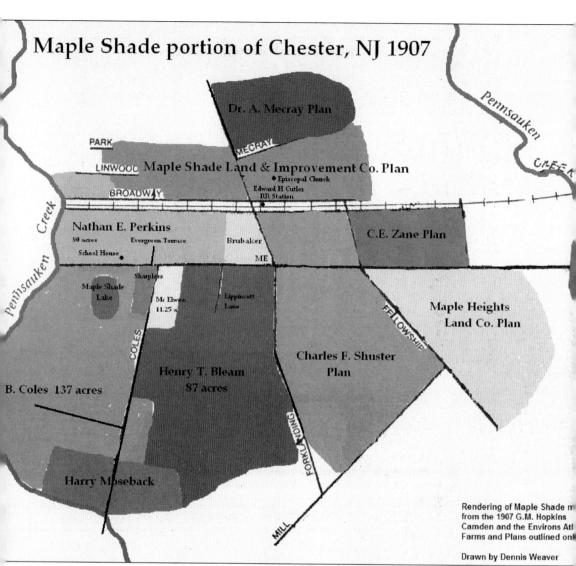

In 1907, the earlier subdivision plans of the Shuster tract and Maple Shade Land and Improvement Company combined with the Maple Heights Land Company plan to sum up the growing vision for the area. Soon after, other nearby farms sold to developers. This map is a rendering by Dennis Weaver of the G. M. Hopkins 1907 Camden and the Environs Atlas, Plate No. 35.

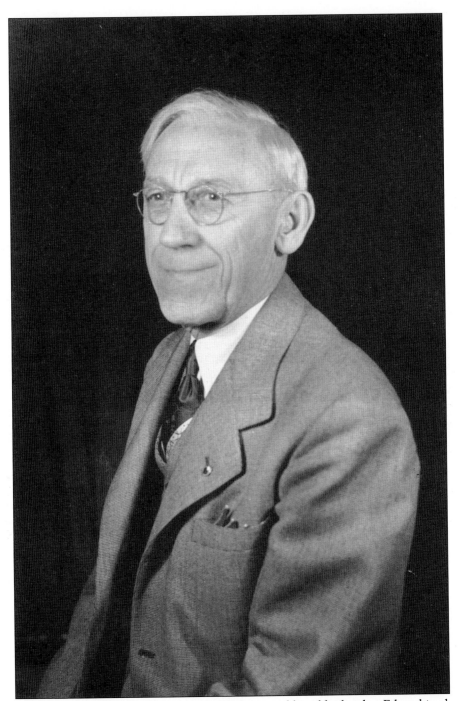

Arthur N. Cutler was born in Berlin. At age 19, he joined his older brother Edward in the real estate business in Philadelphia at a firm called Anderson and Cutler. In 1909, Edward bought out Mr. Anderson's interest and incorporated under the name of the Edward H. Cutler Company, taking Herbert H. Walker as a partner. The business was successful, and in 1918, Edward and Arthur purchased Walker's interest and closed the Philadelphia office, opening others in Collingswood and Maple Shade. (Courtesy Maple Shade Historical Society.)

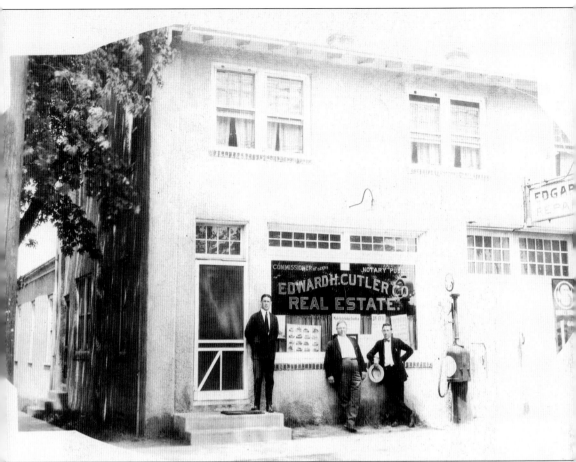

When Edward died, Charles L. Cutler was made president and Arthur became secretary and treasurer. In 1925, large offices were built in Collingswood, with a smaller office in Maple Shade. Later Arthur incorporated a new company, then known as the Cutler Company and since 1939 as the Cutler Agency. As president of the company, he took over the Maple Shade business, which grew to large proportions. He later was a founder of the Maple Shade Historical Society and was its first president. (Courtesy Maple Shade Historical Society.)

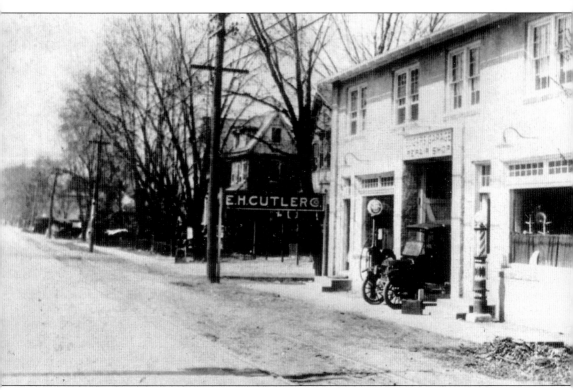

During the spring of 1913, Arthur N. Cutler built a one-room brick real estate office at the northeast corner of Main Street and Poplar Avenue. The company occupied this office until shortly after World War I, when it was enlarged to three stores, two apartments, and a large garage in the rear. The addresses were 201, 203, and 205 East Main Street and contained the Edward H. Cutler Real Estate Office, Gerardo Ventura Barber Shop, and the William Edgar Garage and Repair Shop in rear. The photograph is from about 1924. (Courtesy Maple Shade Historical Society.)

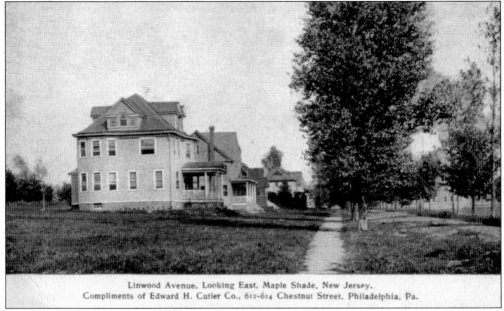

Linwood Avenue, Looking East, Maple Shade, New Jersey.
Compliments of Edward H. Cutler Co., 612-614 Chestnut Street, Philadelphia, Pa.

This postcard, labeled "Linwood Avenue, Looking East," was from the Edward H. Cutler Real Estate Company. The house in front, now 19 East Linwood Avenue, was built in 1906 and was Edward H. Cutler's home. The second house back was built in 1914 for John H. Parker. The Cutler Agency took over the Maple Shade Land and Improvement Company and Charles F. Shuster plan sales of lots. (Courtesy Harry Mergard.)

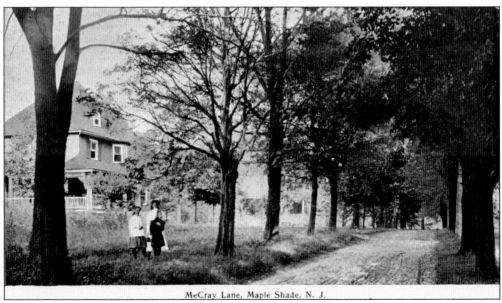

McCray Lane, Maple Shade, N. J.

Shown here is a Mecray Lane postcard from the Edward H. Cutler Real Estate Company. (Courtesy Maple Shade Historical Society.)

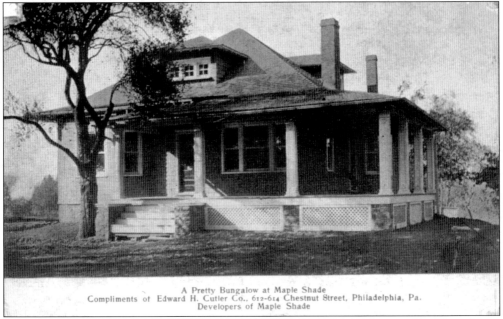

A Pretty Bungalow at Maple Shade
Compliments of Edward H. Cutler Co., 612-614 Chestnut Street, Philadelphia, Pa.
Developers of Maple Shade

This "Pretty Bungalow" postcard was from the Edward H. Cutler Real Estate Company. It is a pretty bungalow with a red, tin roof and now has an enclosed porch. The address is 41 Mecray Lane. Another version of this postcard is titled, "Charming Bungalow." (Courtesy Maple Shade Historical Society.)

This bungalow home at 62 East Park Avenue was built in 1910 by Arthur N. Cutler for himself and his wife, Mary L. (Fahr) Cutler, who were married August 18, 1910, and moved into the house on August 25. Later he lived at 11 South Lippincott Avenue. (Courtesy Maple Shade Historical Society.)

This house is located at 9 Mecray Lane and was built for Herbert H. and Nancy (Mecray) Bartlett about 1910. (Courtesy Maple Shade Historical Society.)

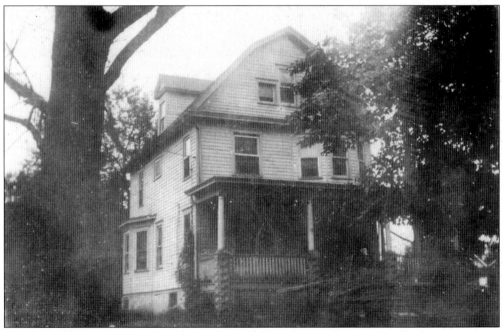
Another old home in town is located at 55 East Linwood Avenue, which was, at one time, the home of Frank A. Harrison. It was built about 1908. (Courtesy Maple Shade Historical Society.)

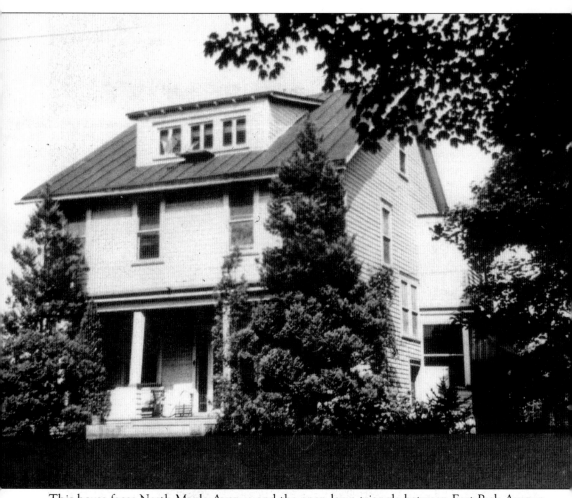

This house faces North Maple Avenue and the open lawn triangle between East Park Avenue and Mecray Lane, but its street address is 103 East Park Avenue. The house was built about 1908 for Daniel and Rose W. Nead. Daniel was a doctor for the Pennsylvania Railroad. The Neads had the house painted boxcar red and trimmed in Pullman car green, but he was transferred by the railroad and was never able to live in the house. The house was later owned by Frank Gerkins, former owner and editor of the *Maple Shade Progress*. (Courtesy Maple Shade Historical Society.)

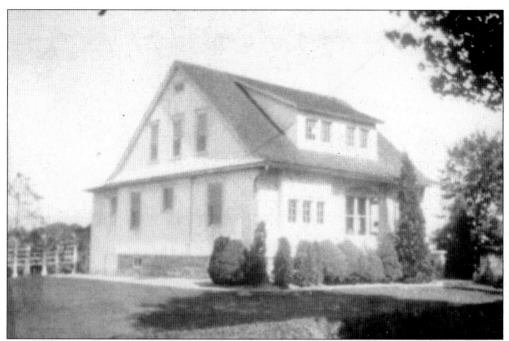

This house was built by the Edward H. Cutler Company at 135 East Park Avenue between 1908 to 1910 for Ted Kellner. Kellner and his wife moved in as newlyweds. (Courtesy Maple Shade Historical Society.)

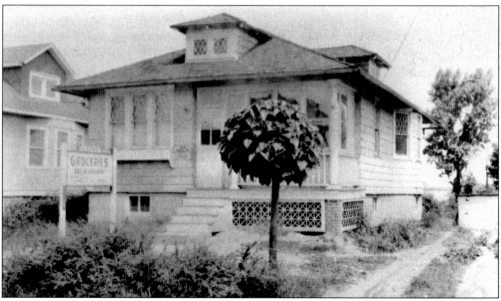

Christian Siegal (or Siegel) and his wife, Ida, moved into this bungalow at 119 West Linwood Avenue in 1917. It was built in 1916, and they were most likely the first owners. For a short time, they had a grocery store at the house. In the days before commercial zoning, mom-and-pop stores and small shops in garages sprung up all over town. (Courtesy Maple Shade Historical Society.)

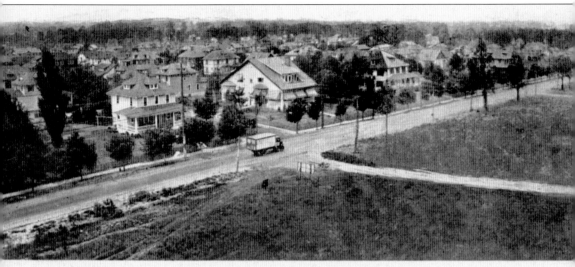

AIRPLANE VIEW OF MAPLE SHADE, SH

Here is an aerial view of Main Street (left) and North Holly Avenue taken about 1926. At left is the Barlow family home and Maple Heights development, and to the right are the Sauselein

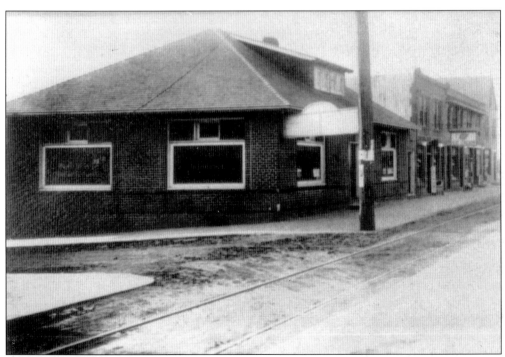

This is a photograph of the Barlow Building on the southwest corner of Main Street and Forklanding Road when it was only one story. (Courtesy Maple Shade Historical Society.)

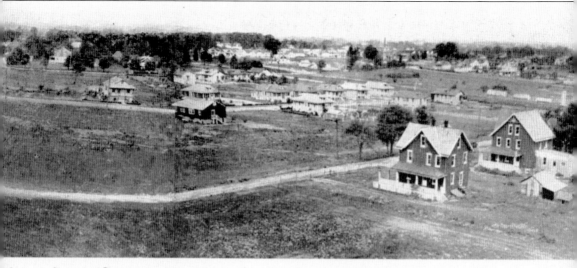

MAPLE SHADE GARDENS ADJOINING

brother's brickyard houses. This photograph was published in Barlow And Company's Maple Shade Gardens brochure around 1926 or 1927. (Courtesy Larry Mesarick and Ray Gangloff.)

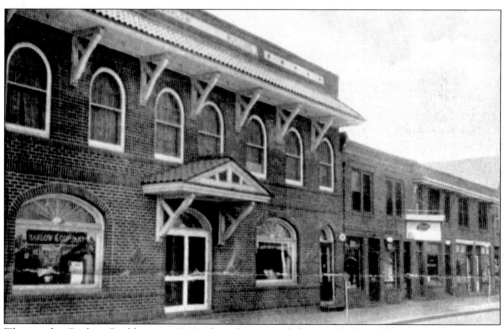

This is the Barlow Building in 1919 after the second floor and the addition in the rear was built. The first office on this corner was wood frame structure built in 1912. About 1914, a brick one-story office was erected. Between 1917 and 1919, a second story was added and it was enlarged to its present size. (Courtesy Maple Shade Historical Society.)

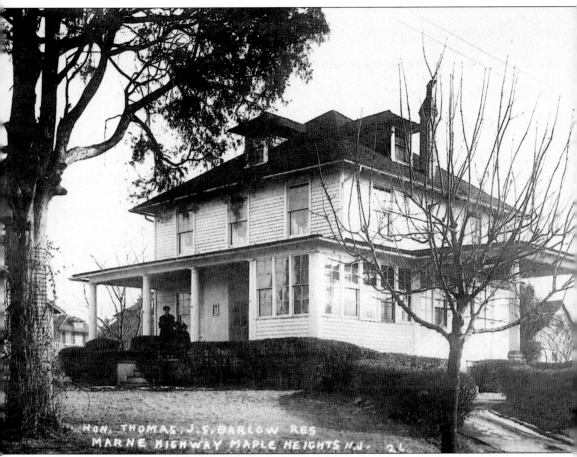

Thomas J. S. Barlow Sr.'s house was at the southeast corner of Main Street and Holly Avenue and is now used as a funeral home. His son Frederick A. Barlow's home was the large bungalow to the left of it, which became the headquarters for the Antrim Menz American Legion Post. It was later razed for the funeral home's parking lot. This photograph was published in Barlow And Company's Maple Shade Gardens brochure around 1926 or 1927. (Courtesy Larry Mesarick and Ray Gangloff.)

Remember We Handle Only the Best

Five-Acre Peach and Apple Orchards, Price, $300 an acre and up.
Five-Acre Poultry and Truck Farms, Price, $100 an acre and up.
Houses, Building Lots and Villa Sites in all parts of New Jersey.

One-Acre Farms Close to PHILADELPHIA

Near train and trolley. Priced at $200 to $500 each on terms of $5 monthly. FOR A SQUARE DEAL, call on or write

BARLOW & COMPANY
Maple Shade, N. J.

Largest One-Acre Farm Developers in the East

DAIRY, GRAIN, HAY and TRUCK FARMS of all sizes and descriptions, in all parts of New Jersey

If you want to sell your farm, list it with us free of charge

Pictured here is a 1913 Barlow and Company advertisement. The company's office was located at the Barlow home at Main Street and Holly Avenue, now a funeral home. Most of the Barlow and Company's advertisements marketed one-acre farms, but today the company is more remembered for their Barlow-built bungalows.

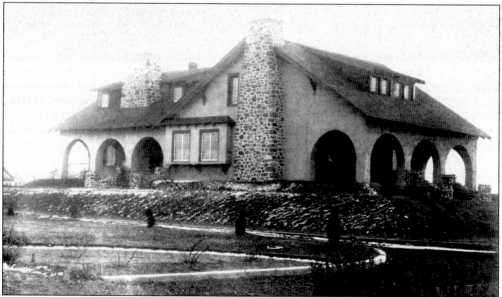

Thomas J. S. Barlow Jr.'s home, shown here, is known as the Barlow Mansion. It was built in 1916 as a wedding present for his wife, Rose. This is the original house. A large, right side addition was added sometime between 1923 and 1926. During the Depression, they lost the home. It later became the restaurant and bar called the Alhambra, Bert's Old Mansion, and Villa Capri Cocktail Lounge. The mansion was destroyed by a fire in January 1963. (Courtesy Maple Shade Historical Society.)

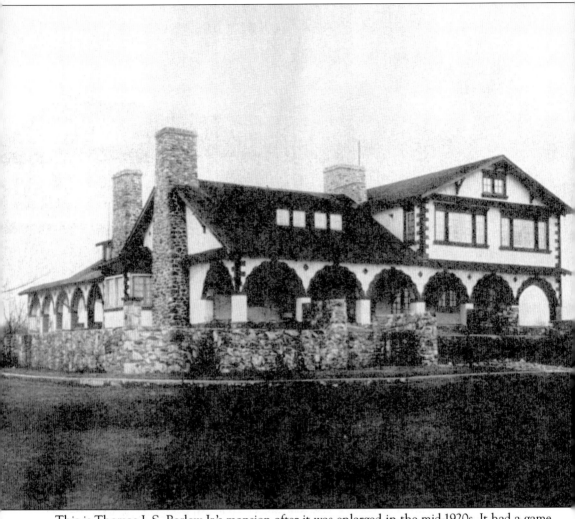

This is Thomas J. S. Barlow Jr.'s mansion after it was enlarged in the mid-1920s. It had a game room where Barlow would let neighborhood kids come and play on Friday nights. The Barlow family lost the mansion during the Depression, and after, it sat empty for years. It was used for a speakeasy until it was padlocked, then the Democrat Club headquarters, and then almost became a mental institution, but the buyer backed out after community protest. It was considered for the township's community house but people sided with the plans that were underway for one to be built at Main Street and North Stiles Avenue, which never was built. It was bought in 1946 and renovated into the Alhambra restaurant and tavern. (Courtesy Maple Shade Historical Society.)

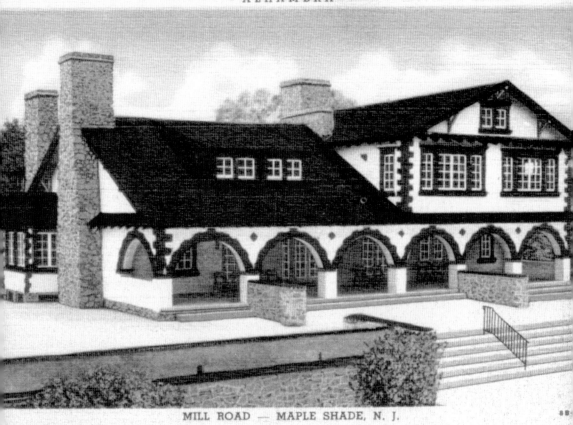

MILL ROAD — MAPLE SHADE, N. J.

This postcard shows the Alhambra. Robert Kennedy bought the Barlow Mansion in October 1946 and turned it into the Alhambra, complete with a rathskeller bar. It was then owned by John and Bertha Czyzewski and called Bert's Old Mansion, where seafood was a specialty. Lastly it was called the Villa Capri Cocktail Lounge and owned by three brothers, Anthony, Vito, and Rudolph Masso. It burned down on the cold morning of Thursday, January 24, 1963. (Courtesy Paul Altobelli.)

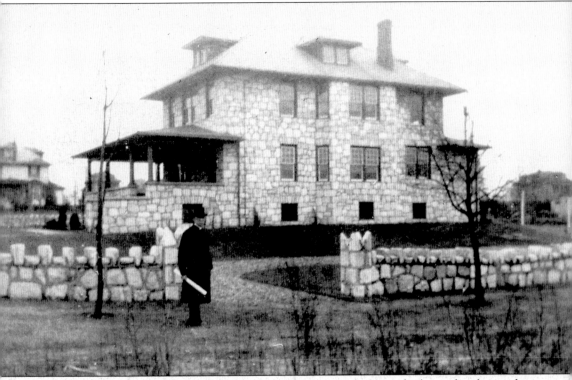

This house was built for Rosa Rynning in 1917 by Oscar Anderson and is located at the northeast corner of Main Street and Walnut Avenue. The attractive two-and-one-half-story home was constructed of white stone with a two-foot-high white stone fence surrounding the yard, at the cost of approximately $12,000. The house was later used as the Our Lady of Perpetual Help Catholic Sisters home and today is used as a children's day care center. (Courtesy Maple Shade Historical Society.)

STREET VIEW, MAPLE SHADE, N. J. (Pub. by Pettit's Drug Store)

Titled "Street View, Maple Shade," this postcard was published by Pettit's Drug Store. The photograph was taken about 1915 and shows the house at 17 North Terrace Avenue, originally built for and owned by Clifford Rapp, and later owned by George Barbour. The house at 25 North Terrace Avenue was built for Harry B. Mennel and later owned by Frederick Young. Both houses were built by John L. Owen of Owens and Stiles builders. Further back is 33 North Terrace Avenue that was, at one time, owned by the Willmunger family. (Courtesy Maple Shade Historical Society.)

COLES AVENUE, MAPLE SHADE, N. J. (Pub. by Pettit's Drug Store)

Published by Pettit's Drug Store, here is a postcard that shows North Coles Avenue and Main Street. Previously this property was Nathan Perkins's farm and was purchased in 1910 by Horace Roberts of Moorestown to be developed into Barlow and Company bungalows. Maple Shade's roads were in bad shape for decades and people called the town "Maple Mud." Throughout the 1920s, only Main Street, Forklanding Road, and Mill Road were paved. The rest were dirt or cinder. (Courtesy Paul Altobelli.)

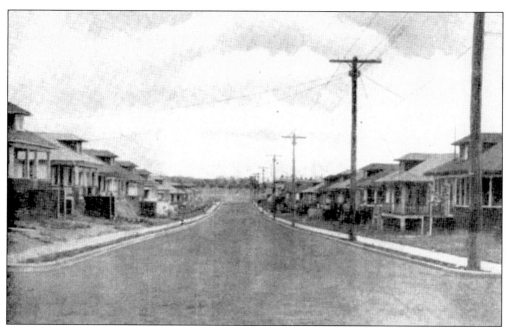

Pictured here are Cedar Avenue bungalows with Maple Shade Gardens in the background. With the nearby waterworks on Main Street, a large number of bungalows were built throughout this section. This photograph was published in Barlow and Company's Maple Shade Gardens brochure around 1926 or 1927. (Courtesy Larry Mesarick and Ray Gangloff.)

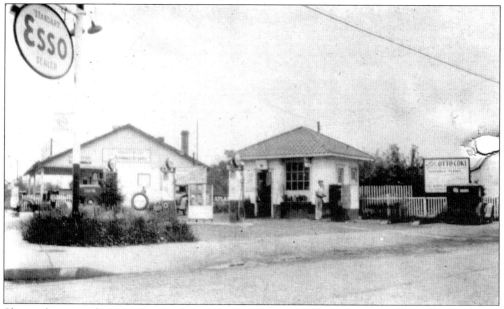

Shown here is Clarence Ward Jr.'s Esso gas station in 1930. It was located at the northwest corner of Main Street and Forklanding Road. In April 1937, John C. Compton bought the gas station. In 1939, he moved it across the street to the southeast corner of Main Street and Margaret Avenue. Later owners included the Poleys and the Anserts. (Courtesy Maple Shade Historical Society.)

Vote Against the Division of Chester Township!

OTHER towns are annexing territory. Are you going to allow Chester Township divide her territory and HAVE HIGHER TAXES?

Then VOTE AGAINST the division, Tuesday, May 22d, from 6 A. M. to 7 P. M.

If You Do Not Want a Higher Tax Rate

	Yes	Shall an act entitled an "Act to incorporate the township of East Chester, in the County of Burlington and State of New Jersey," be adopted.
X	No	

Mark an X in black ink or black pencil opposite the word "NO" on May 22d, on your ballot, as above. This means a vote against increased taxes.

The *Maple Shade Progress* newspaper was first published in 1916 on the eve of an election with local Theodore Sauselein running to be on the township committee. Chester Township at the time included Moorestown, Lenola, and Maple Shade. Maple Shade wanted progress in the form of better roads, streetlights, water, utilities, and so on. Instead, Moorsetown's plan was to separate with Lenola from Chester Township, leaving Maple Shade behind. The election was lost, and they did not, until they voted by themselves, and separated from Chester Township in 1922. Maple Shade was the last part of Chester Township and remained unincorporated until 1945 when the town's name officially changed to Maple Shade. (Courtesy Maple Shade Historical Society.)

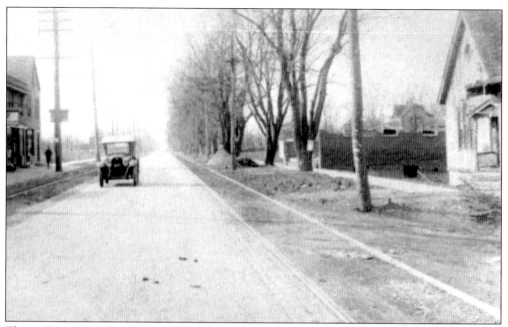

This is West Main Street and Forklanding Road looking west about 1922. The Congregational Church and the Maple Shade Betterment League community hall, under construction, are on the right. Brick stores are on the left. Note the large silver maple trees along Main Street on what was the Elam Brubaker farm. (Courtesy Maple Shade Historical Society.)

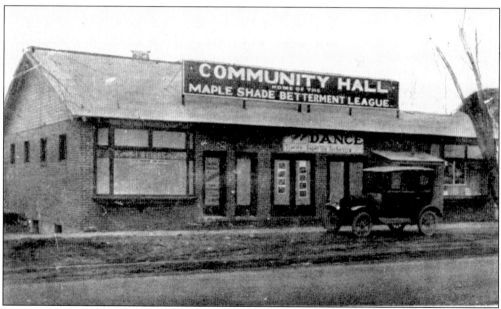

The Maple Shade Betterment League formed in 1922 for "the social welfare and civic betterment of the entire community of Maple Shade." One achievement was the building of a community house on the north side of Main Street west of Forklanding Road. The hall was used for meetings, socials, minstrel shows, movies, and dances. After the depression, it became a gas station and then the Victory Cafe bar. (Courtesy Maple Shade Historical Society.)

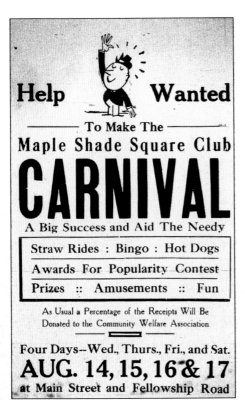

There was an athletic field complete with bleachers along the northeast corner of Main Street and Fellowship Road. This was the site of many carnivals. The Square Club building on North Fellowship Road is now used by the Masons. This is an advertisement from the *Maple Shade Progress*.

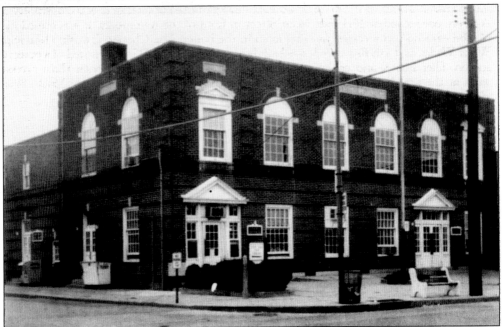

Here is the old Maple Shade municipal building as it looked in 1967. In the early 1990s, the Maple Shade municipal complex was moved to the newly renovated old coat factory, formerly known as Warwick Fashions and E. W. Twitchell. In 1995, the old building was sold to the Vojnika family who turned it into the Café Fontana restaurant. (Courtesy Maple Shade Historical Society.)

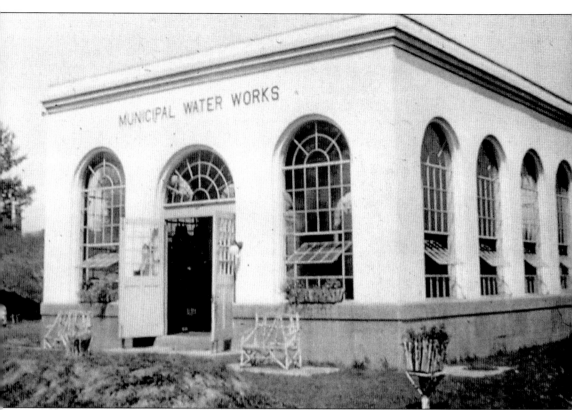

A house once stood at 1011 East Main Street in front of the waterworks. It was owned by a Mr. Brown who had a carpet weaving loom in the house. The Chester Township Municipal Water Works, as it was first called, was built between 1923 and 1925. It consisted of a pumping station, filter house, and concrete settling basin. Water was obtained from three artesian wells at the site. Eckard Gibbs served as the first superintendent. (Courtesy Maple Shade Historical Society.)

4 DIFFERENT TYPES AND PRICES

There's One to Suit YOU!

- 2 BEDROOMS $7995
- 2 BEDROOMS WITH EXPANDABLE ATTIC $9250
- 3 BEDROOMS $8795
- 3 BEDROOMS $9250

All the homes have a large unfinished second floor with fold-a-way stairway . . . ideal for storage.

4¼% FHA FINANCING

PRICE	$
MORTGAGE	$
DOWN PAYMENT	$
MONTHLY CARRYING CHARGES	
Interest & Principal	$
Taxes (approx.)	$
Fire Insurance	$
TOTAL MONTHLY COST	$
Average monthly saving	$
NET MONTHLY COST	$

ALDEN PARK
MAPLE SHADE CONSTRUCTION CO.
MERCHANTVILLE 8-9353

ALDEN PARK
A NEW PLANNED COMMUNITY OF 500 SINGLE HOMES
MAPLE SHADE, N. J.
ON MOORESTOWN PIKE BETWEEN MERCHANTVILLE AND MOORESTOWN
15 Minutes to Central Philadelphia
Minutes to Tacony-Palmyra Bridge

Homes with gable fronts slightly higher in price

Ranch Type Homes

- MANY BEAUTIFUL EXTERIOR DESIGNS
- FOUR DIFFERENT FLOOR PLANS
- TWO OR THREE BEDROOMS
- LARGE LOTS, NONE SMALLER THAN 60' x 11

$7995
Others at $8795 and $9250

RECORD-BREAKING VALUE • CAN'T BE DUPLICATED

Seen here is a 1950s Alden Park homes brochure. Debbie Vit's parents purchased a ranch in Alden Park and saved this brochure. Her father's notes on different mortgage rates are on the back. With the post–World War II developments of Maple Park Manor, Park Estates, and Alden Park in the 1950s, Maple Shade grew to have the second largest township population in Burlington County. (Courtesy Debbie Vit.)

Four

CHURCHES

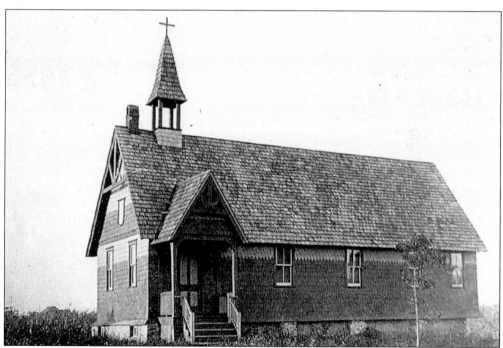

The first St. John's Episcopal Church was started in April 1888 with 24 members attending. Services were held in the home of railroad agent William J. Broadwater, located on Main Street near Spruce Avenue. In 1889, a plot of land at the northeast corner of Main Street and Fellowship Road was leased for $1 from Charles Zane for 10 years. A frame chapel, which became St. John's Episcopal Mission was built and dedicated on July 15, 1890. The church was only five years old when it was destroyed by a fire on June 21, 1895.

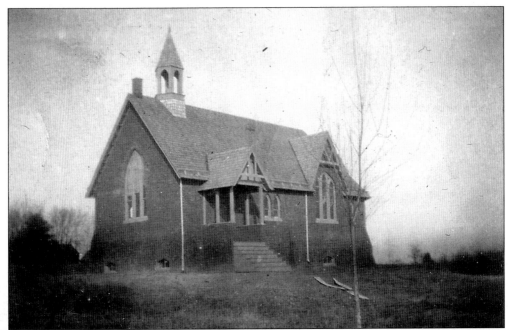

Within a month after the first church was lost to a fire, parishioners were preparing to build a new one. Dr. Alexander Mecray offered a portion of his property on East Linwood Avenue as the site. The new brick building was completed and dedicated in September 1896. (Courtesy Maple Shade Historical Society; photograph by George DeCou.)

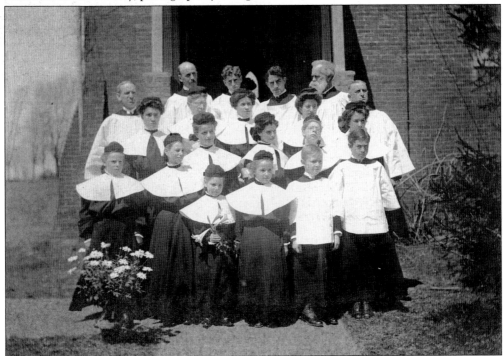

This is a 1909 photograph of St. John's Episcopal Church choir. (Courtesy Maple Shade Historical Society.)

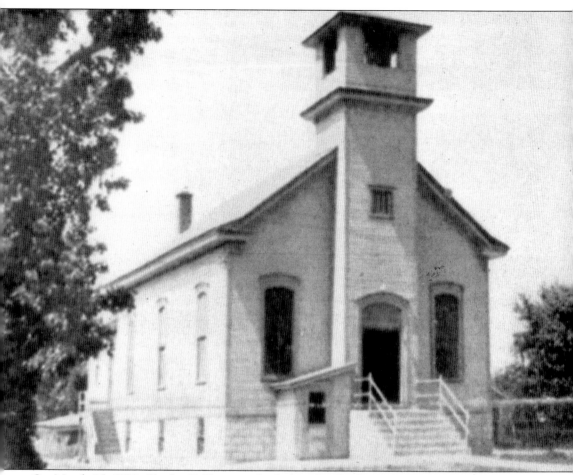

On March 25, 1890, Charles F. Shuster, who began the development of Maple Shade, sold a lot at Main Street and South Poplar Avenue to the Moorestown Baptist Church for the sum of $1 with the condition that the property never be used for anything other than church purposes. In October 1924, under the direction of Pastor George W. Crane, the Fellowship Baptist Chapel, built in early 1870, was moved from its place in Fellowship, Mt. Laurel, a distance of over three miles, down Fellowship Road and across the back of the Our Lady of Perpetual Help Church lot to its place on South Poplar Avenue. This photograph shows Immanuel Baptist Church as it looked in the mid-1920s. The original church had a wing added in 1953. A renovation and a large sanctuary were added under Pastor Herbert W. Mitchell, with the cornerstone laid on November 27, 1966, and the dedication held on Sunday, June 11, 1967. (Courtesy Maple Shade Historical Society.)

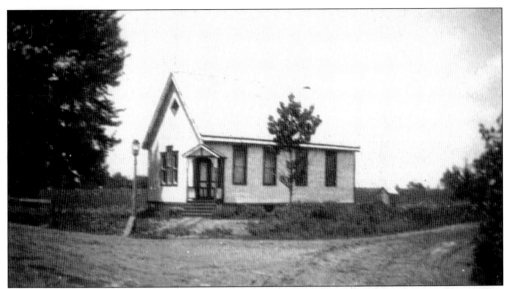

First Methodist Church services were held in the home of Elam Brubaker, who settled in Maple Shade in 1885. Brubaker donated a parcel of his land at the northwest corner of Main Street and Forklanding Road as a site for a Methodist church. A small chapel was built in 1891, but services were held for only a short time. In 1906, the chapel was used for a Union Sunday school. The Reverend Daniel McAllister, a Congregational minister, was called to pastor in 1908, and in February 1909, the church was accepted into the General Council of Congregational Christian Churches. (Courtesy Maple Shade Historical Society; photograph by George DeCou.)

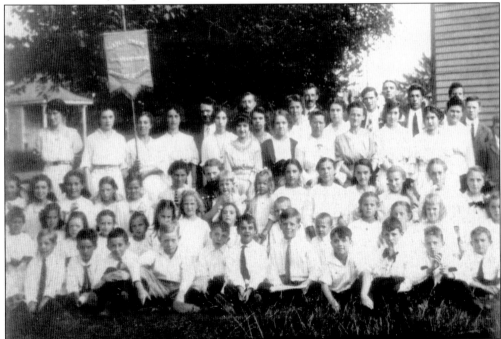

The Congregational Church Sunday school in back of the former Methodist church building is shown here. The Edward H. Cutler real estate field office can be seen in the background across the street on North Forklanding Road. (Courtesy Maple Shade Historical Society.)

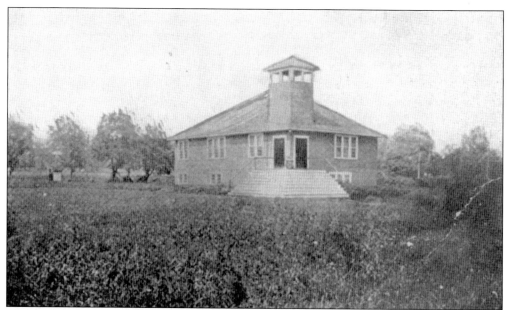

This is a postcard of the Congregational church at North Forklanding Road and Theodore Avenue. The church moved from the old Methodist chapel that was then used by Elam Brubaker for his uniform factory. The Congregational Church was planning to build at the southwest corner of Main Street and Maple Avenue in 1917 under Rev. E. Stanton Yoder, but decided on this Sauselein tract land instead. (Courtesy Maple Shade Historical Society.)

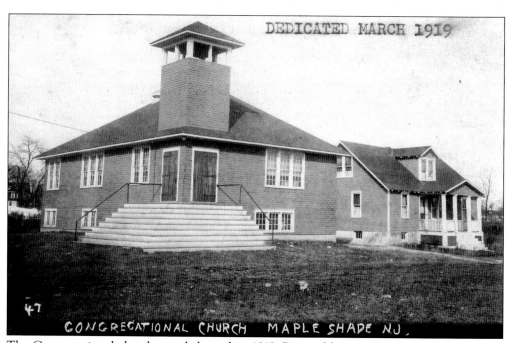

The Congregational church was dedicated in 1919. Pictured here is the pastor's home on the right. Alterations were later done in 1955 and a new and larger church was built. A new sanctuary was started in 1962 and was dedicated in 1963. (Courtesy Maple Shade Historical Society.)

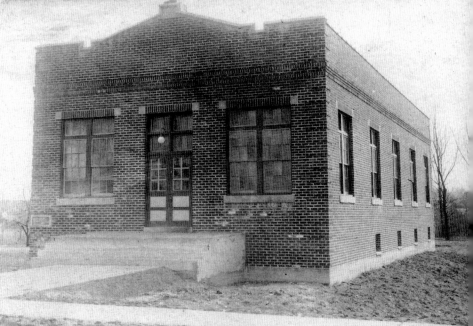

In May 1919, the Maple Shade Parish was incorporated and became a mission of Our Lady of Good Council in Moorestown. The first mass was celebrated in the large, brick Stiles homestead at Linwood and Stiles Avenues. As the congregation grew, services were moved to North Poplar Avenue School No. 1 for about a year. During that time, construction began on the first Roman Catholic Church in Maple Shade. Its first mass was held in April 1921. In 1954, under the guidance of Fr. Thomas F. Nolan, a beautiful new Catholic church was built on South Fellowship Road. Today's church has a 100-foot tower with bell chimes. (Courtesy Maple Shade Historical Society.)

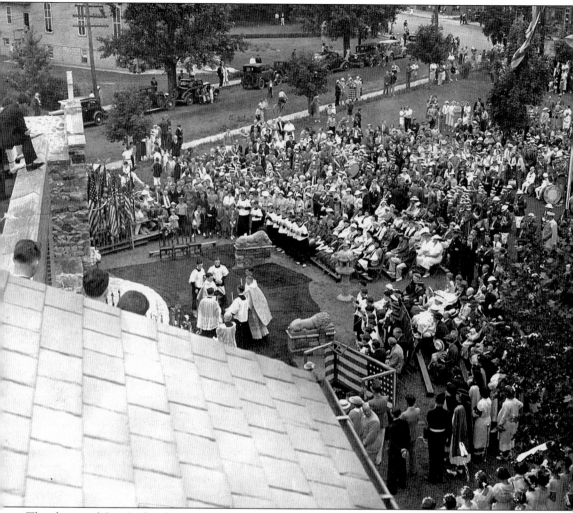

The shrine of Our Lady of Perpetual Help was at Main Street and South Poplar Avenue, now the site of the Our Lady of Perpetual Help School addition. The shrine was formally dedicated on Sunday, August 15, 1937. The history of the shrine is that it stands out as unique in the history of Catholic parochial life. It was built by members of the parish under the direction of the Reverend George E. Duff, who was pastor of the church. It was used on June 20, 1937, for a gigantic field mass held in conjunction with the American Legion's Drum and Bugle Corps competition. (Courtesy Maple Shade Historical Society.)

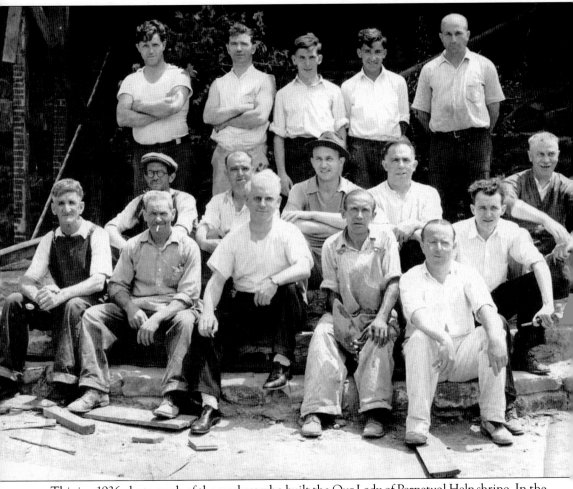

This is a 1936 photograph of the workers who built the Our Lady of Perpetual Help shrine. In the second row, second from the left, is Frank J. Duetsch. He was a carpenter by trade, an Our Lady of Perpetual Help Church member, and an usher for the church. (Courtesy Robin Cucinotta.)

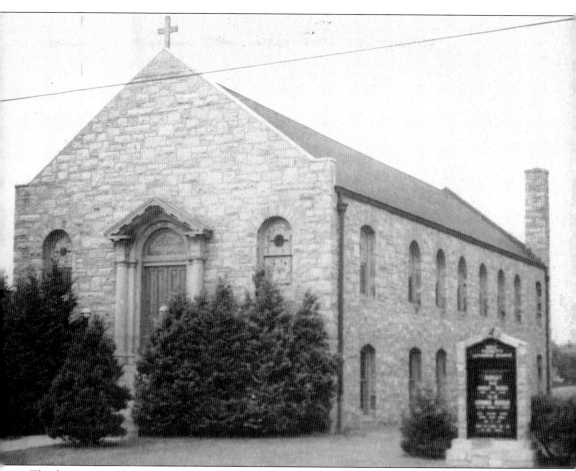

The first service of the Holy Trinity Lutheran Church was attended by 10 people who assembled in the Barlow Building on June 26, 1927. For a number of years the congregation held their services in the Square Club on North Fellowship Road (now the Masonic building). The Reverend Ralph J. Steinhauer began his pastorate in 1934, and plans were soon started for the church on South Forklanding Road. The building has an interesting history in that the stone walls, front doors, and timbers were reused from the old Camden City Hall, which was, at the time, being torn down. The new church was completed and dedicated on February 17, 1935. In May 1961, a new sanctuary was built beside the older building, pictured here, which was then used as the educational building. (Courtesy Maple Shade Historical Society.)

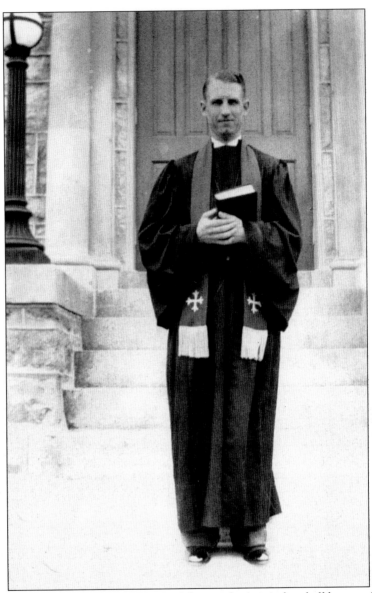

The Reverend Ralph J. Steinhauer gave up a professional career in baseball because he felt called to the ministry. Another interesting fact is that he filled in for a schoolteacher for a period when more were needed in town. He began his pastorate in 1934 with the building of Holy Trinity Lutheran Church. Steinhauer devoted his entire 32-year pastorate to this church. He was very civic minded and became the president of the Community Memorial Association of Maple Shade that planned to build a community house at the northeast corner of Main Street and Stiles Avenue. On April 6, 1946, there was a Welcome Home Day parade with over 800 war veterans from Maple Shade honored, and the cornerstone was laid for the community house. Probably due to a lack of funds, nothing more became of the community house project. Steinhauer died in 1966, and thousands attended his funeral. He was much loved for his contributions to the town. Chestnut Avenue School No. 2, then the Maple Shade Junior High School, and a park built at the southwest corner of Main Street and Coles Avenue were both dedicated to his memory and named for him. (Courtesy Maple Shade Historical Society.)

Five

SCHOOLS

In 1784, the Chester Preparative Meeting of Friends purchased a lot from Job and Ann Cowperthwaite and built a brick schoolhouse to replace a frame schoolhouse. The school was built on Old Ferry Road where it branched off Kings Highway. Later only this small portion of Old Ferry Road remained and was renamed Schoolhouse Lane. In 1872, the school passed under control of the county and became a public school. In 1917, it closed and was sold to Joseph Matlack, who used it to house blueberry pickers during summers. It was later destroyed by a fire. (Courtesy Maple Shade Historical Society.)

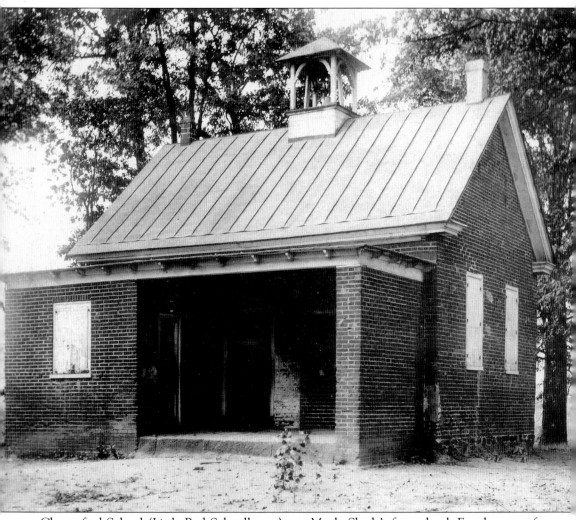

Chesterford School (Little Red Schoolhouse) was Maple Shade's first school. For the sum of $1, on December 16, 1811, Joseph Burroughs deeded the lot on West Main Street for a brick schoolhouse to be built because of his natural love and regard for literature and for other diverse causes. It was built in 1812 and is located on Main Street, west of Coles Avenue. It was used until 1909 and the last teacher was Pricilla Gardiner. (Courtesy Maple Shade Historical Society.)

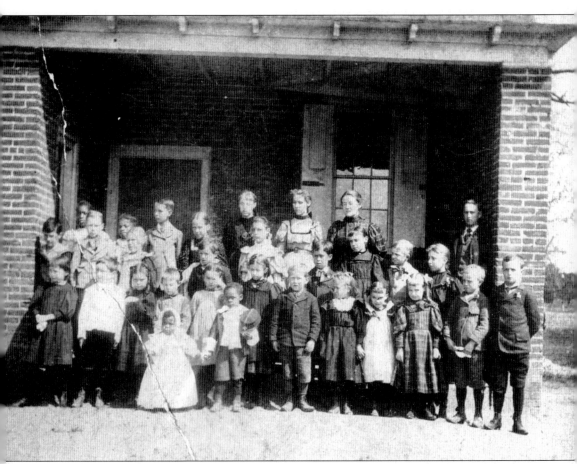

Chesterford School class of 1897 is pictured here. Included in the photograph are teacher Miss Lippincott, Charles Fahr, Mary Fahr, Martha Lippincott, Gertrude Brubaker, Mary Hintermeier, Elva Haines, Carrie Haines, and Tessie, Benjamin, and Ralph Davis. (Courtesy Maple Shade Historical Society.)

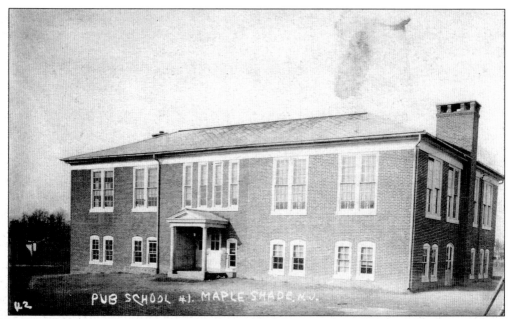

School No. 1 opened in 1909. It was later named the Haig School in honor of Elizabeth Haig, who was principal from 1919 until 1965. It was originally a two-room brick building located on Poplar Avenue. (Courtesy Maple Shade Historical Society.)

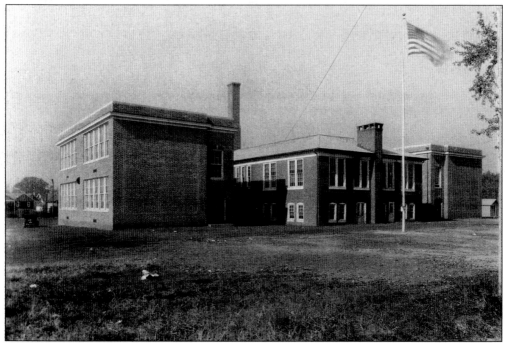

The school was enlarged in 1914 with the addition of two more rooms. With a growing enrollment, two wings of four more rooms each were added in 1926. (Courtesy Maple Shade Historical Society.)

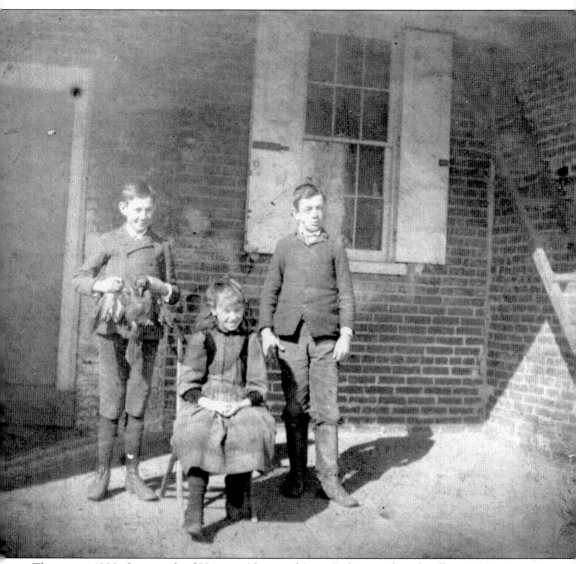
This is a c. 1900 photograph of Horace, Alice, and Isaac Perkins at the schoolhouse. Horace is proudly displaying his catch.

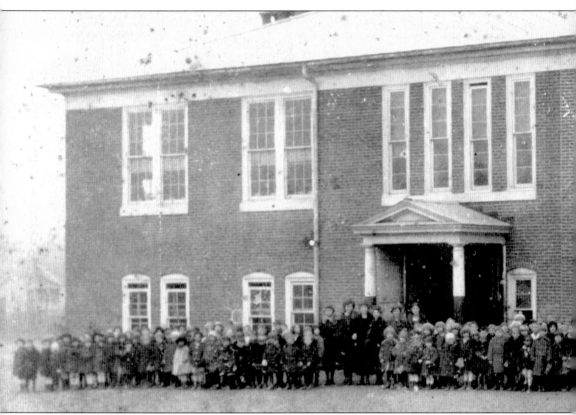

School No. 1 (the Haig School) is shown here with all faculty and students during picture day

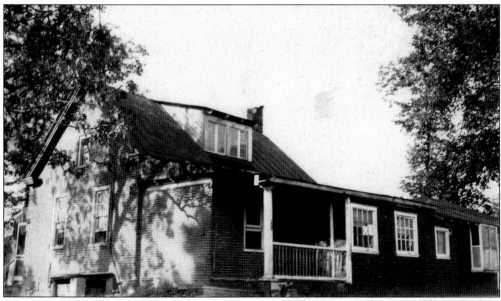

The Chesterford School (Little Red Schoolhouse) was once used as a store. The township foreclosed on the store for nonpayment of taxes and returned it to its original state. (Courtesy Maple Shade Historical Society.)

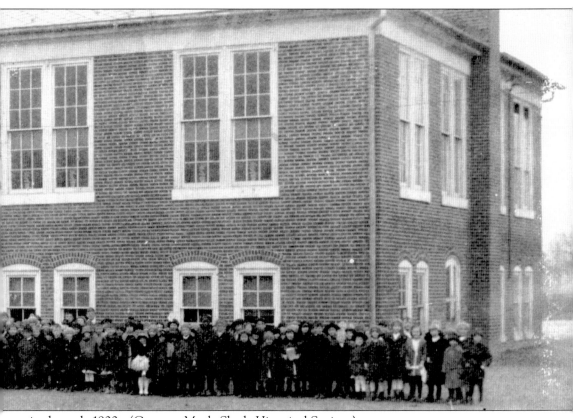
in the early 1900s. (Courtesy Maple Shade Historical Society.)

Chesterford School is picture here in April 1897. (Courtesy Maple Shade Historical Society.)

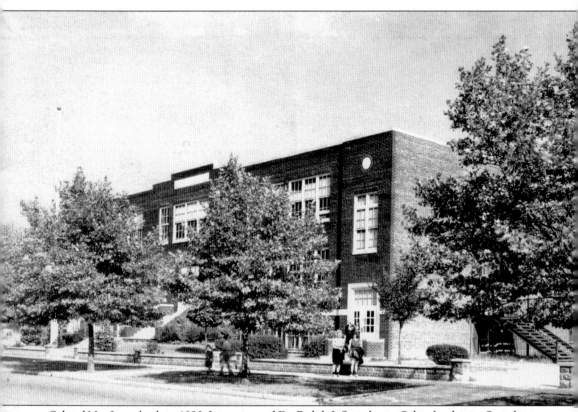

School No. 2 was built in 1920. It was named Dr. Ralph J. Steinhauer School to honor Steinhauer, who had been pastor of the Trinity Lutheran Church. By 1926, the schools were overcrowded and, from September 1926 to February 1927, classes were on part-time sessions. (Courtesy Maple Shade Historical Society.)

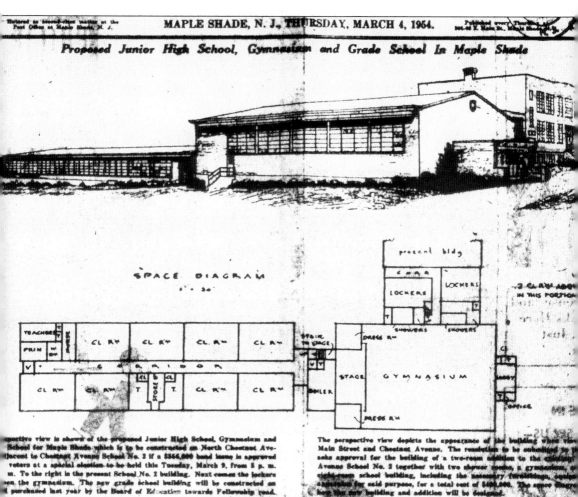

School No. 2 was again expanded 1954. There was a 12-room addition with an auditorium dedicated in September 1955. The one-time junior high school later became the school for the fifth and sixth grades. During the 2006–2007 school year, there was considerable reconstruction. (Courtesy Maple Shade Historical Society.)

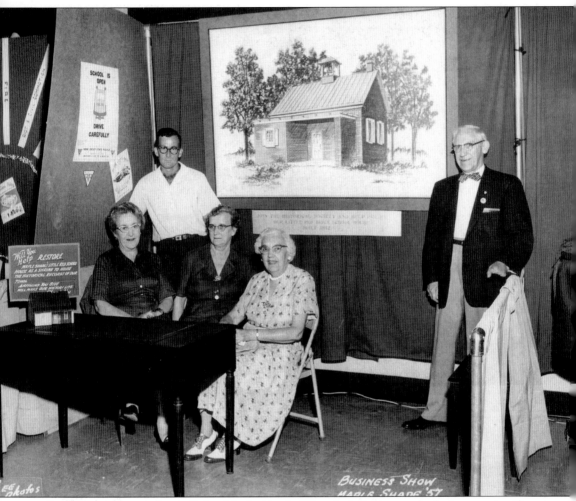

In 1957, many members of the Maple Shade Historical Society embarked on a significant restoration project. Fifty years later, the members of the society are doing the same. Pictured, from left to right, are Irene Luft, Frank Romano, Lila Johnson, Mary Cutler, and Arthur N. Cutler. (Courtesy Maple Shade Historical Society.)

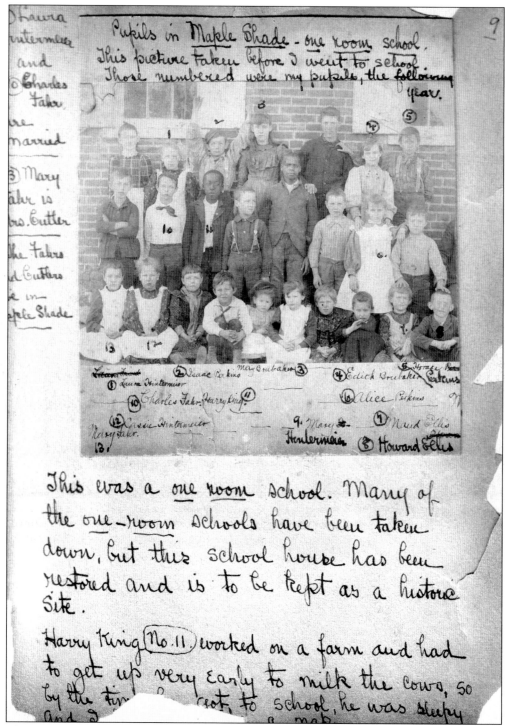

This is a c. 1900 class picture from Chesterford School (Little Red Schoolhouse). Included in the picture are Charles Fahr, Mary Fahr, Harry King, Isaac Perkins, Alice Perkins, Howard Ellis, and Mary Brubaker. (Courtesy Maple Shade Historical Society.)

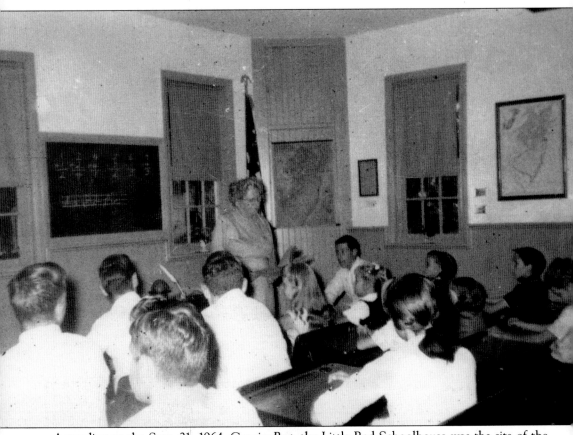

According to the Sept. 21, 1964, *Courier-Post*, the Little Red Schoolhouse was the site of the reenactment of classes when Elizabeth B. Haig taught attentive pupils for the benefit of many visitors attending the open house. (Courtesy Maple Shade Historical Society.)

Six
POLICE AND FIRE DEPARTMENTS

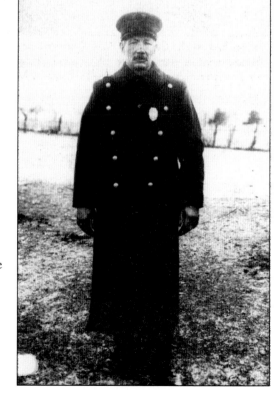

Maple Shade's first police officer and chief, Clarence L. E. Ward, is pictured here. On February 1, 1914, Ward was appointed the first patrolman of the township and became chief of the one-man department. As the department expanded, he remained chief. He retired in 1937 after 23 years of service. He also served as constable of Chester Township when it embraced Maple Shade, Moorestown, and Lenola. In addition, he was a deputy tax collector. (Courtesy Maple Shade Historical Society.)

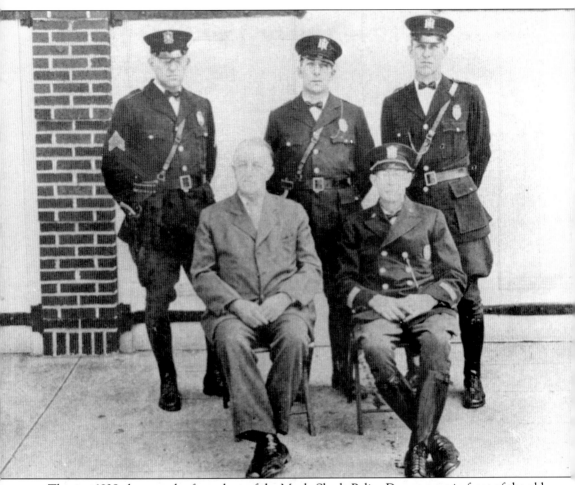
This is a 1938 photograph of members of the Maple Shade Police Department in front of the old municipal building. Pictured, from left to right, are (first row) police recorder Alfred M. Addison and Chief Clarence L. E. Ward; (second row) Sgt. Leroy Jackson, patrolman Grover Lentz, and patrolman John Siebke. (Courtesy Maple Shade Historical Society.)

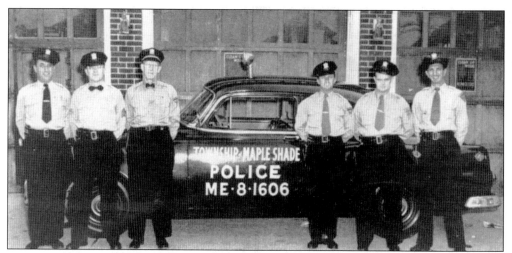

Shown here are policemen in front of police car. Pictured, from left to right, are Mike Lombardi, Al Brooks Jr., Chief John Siebke, Ben Whitcraft, Bob Fries, and Pete Amorosi in front of the firehouse. The firehouse is now Fontanas Restaurant. (Courtesy B. Franklin Brooks.)

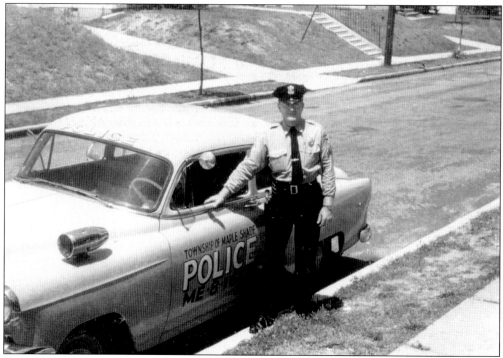

Sgt. Al Brooks Jr. poses with a 1965 Chevrolet police car in front of his parent's house at 103 South Coles Avenue. Later he became chief of the Maple Shade Police. (Courtesy B. Franklin Brooks.)

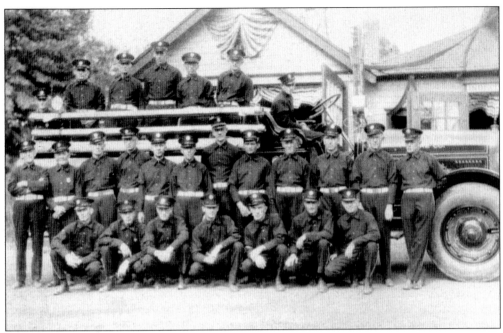
This is a 1925 photograph of the Maple Shade Fire Department with their 1925 Seagrave pumper in front of the first firehouse. (Courtesy Maple Shade Historical Society.)

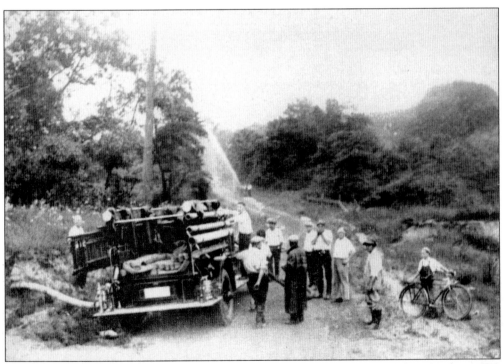
The Maple Shade Fire Department tests the Seagrave pumper at the Pennsauken Creek in 1926. (Courtesy Maple Shade Historical Society.)

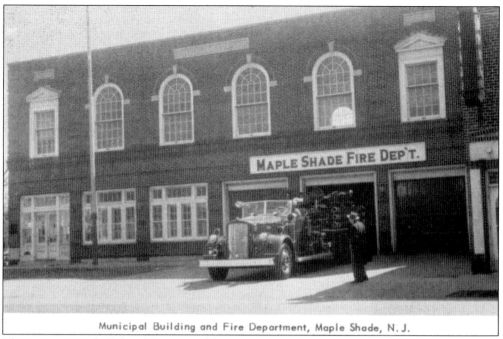

This is a postcard of the old municipal building and firehouse built in 1927. (Courtesy Maple Shade Historical Society.)

Pictured here is future fire chief Harry McCalla in the Fourth of July parade, marching along Main Street towards Lippincott Avenue. (Courtesy B. Franklin Brooks.)

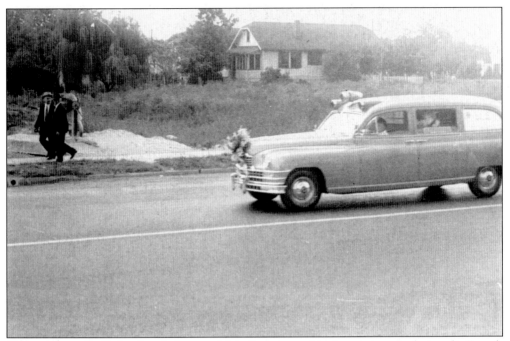

Shown here is the Packard ambulance at Main Street near Lippincott Avenue during the Fourth of July parade. (Courtesy B. Franklin Brooks.)

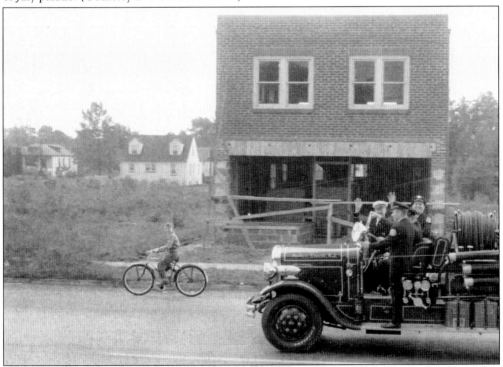

The Hahn fire truck moves along Main Street near Lippincott Avenue. The metropolitan building would later be built to the left of this building seen here. Mr. Geiger, a plumber, owned the house. (Courtesy B. Franklin Brooks.)

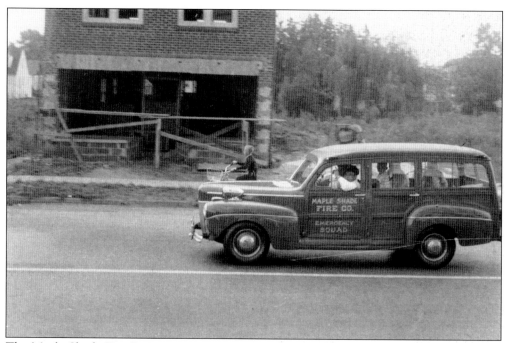

The Maple Shade Fire Department station wagon is seen here in the Fourth of July parade. (Courtesy B. Franklin Brooks.)

Fire Chief Al Brooks Sr. is pictured in front of the old municipal building that housed both the fire and police departments. (Courtesy B. Franklin Brooks.)

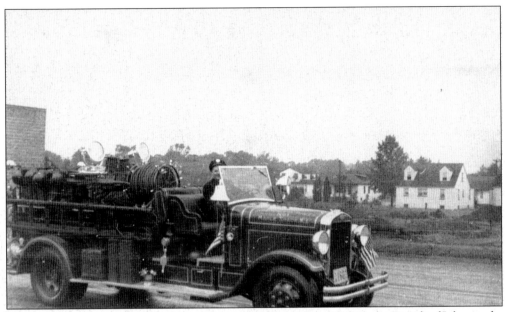

Pictured here is the Maple Shade Fire Department Hahn fire engine in the Fourth of July parade. (Courtesy B. Franklin Brooks.)

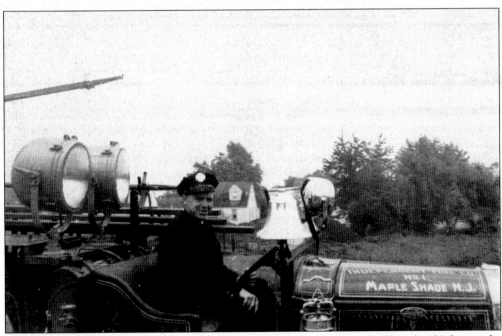

The Maple Shade Fire Department Ford fire engine is seen here in the Fourth of July parade. (Courtesy B. Franklin Brooks.)

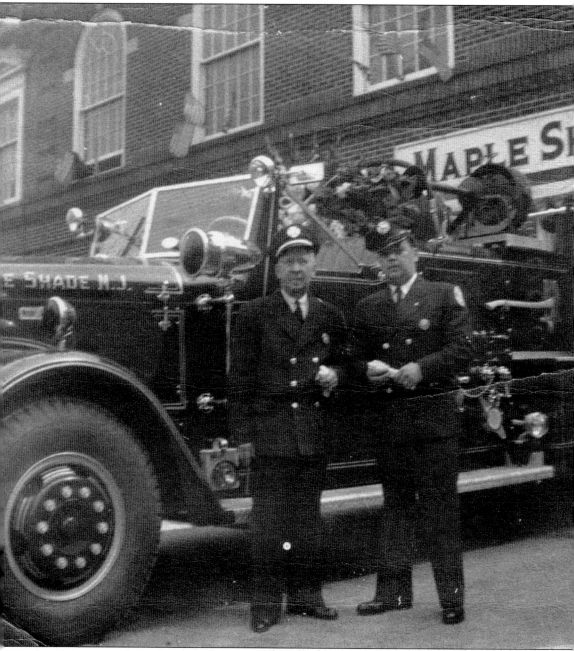

Harry B. Mennel Sr. and Harry B. Mennel Jr. are pictured here in 1952 at the housing of the La France No. 1 fire truck. (Courtesy Karen Mennel Pike.)

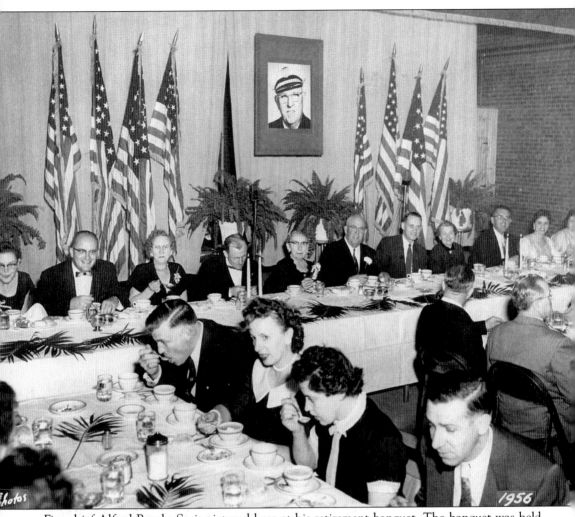

Fire chief Alfred Brooks Sr. is pictured here at his retirement banquet. The banquet was held at the Maple Shade firehouse. Pictured, from left to right at the back table, are Claire Brooks, Al Brooks Jr., Mrs. Moore, Fred Moore, Rachel Brooks, Al Brooks Sr., Pastor Steinhauer, Mrs. Steinhauer, Frank Brooks Sr., Emma Brooks, and Frank's sister Bertha Brooks. At the left front table from back to front are George Roats and his wife, Laura, and Betty and Art Hainely. The people at the right front table are unidentified. Alfred C. Brooks Sr. became a member of the fire department in 1920, was elected chief in November 1935, and retired in November 1955. His retirement dinner in 1956 was the first affair held in the new firehouse on South Maple Avenue. He also served as superintendent of the township water and sewer departments. (Courtesy B. Franklin Brooks.)

Seven
MAIN STREET AND STORES

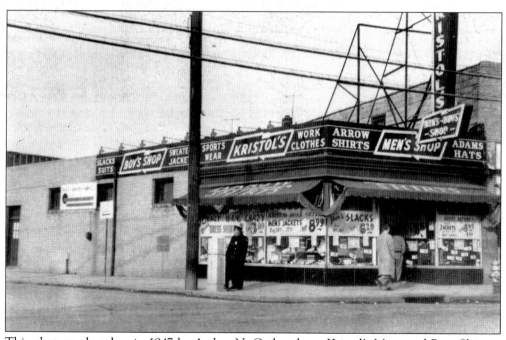

This photograph, taken in 1947 by Arthur N. Cutler, shows Kristol's Mens and Boys Shop at the northeast corner of Main Street and Forklanding Road where the first Childs store and American store stood.

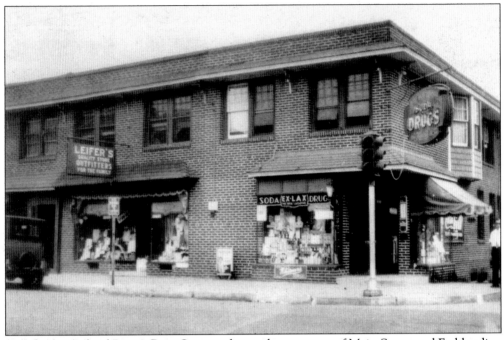

Seen here is Roland Pettit's Drug Store at the southeast corner of Main Street and Forklanding Road. Later it was called Maple Shade Pharmacy. Leifer's Clothing Store was next door. (Courtesy Cutler family.)

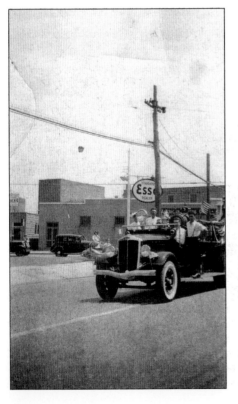

This is a 1937 parade scene at Main Street and Forklanding Road. The American store is in the background of Compton's Esso station. At the time, the Taxi bar was known as Heck's Restaurant. (Courtesy Virginia Harris and the Bechler family.)

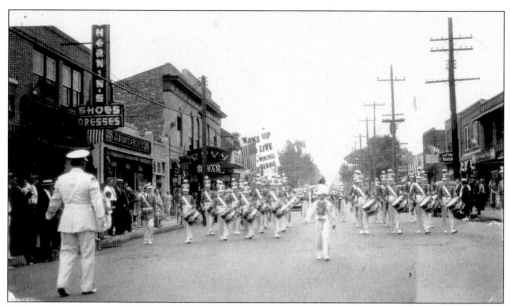

Here is another view of the 1937 parade. *Wake Up and Live* is playing at the Roxy Theatre. (Courtesy Virginia Harris and the Bechler family.)

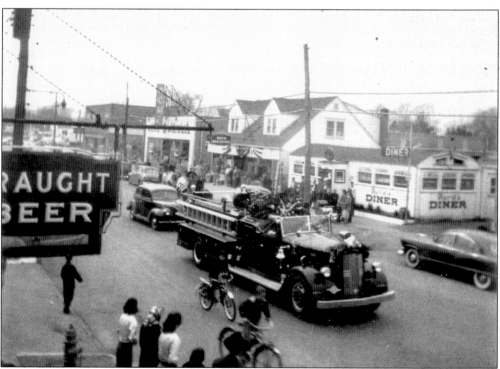

This photograph was taken before 1954 because, in October 1953, the new Acme Supermarket near Lippincott Avenue opened. The Acme, as seen in the photograph, was located where Smith Brothers drug store now is, and in 1954 was turned into a Furniture By Marks store. The next store is Main Street Hardware, run by the Schwartz family, and then Byrd's Diner that is said to have been run by Henny Christiansen. (Courtesy Virginia Harris and the Bechler family.)

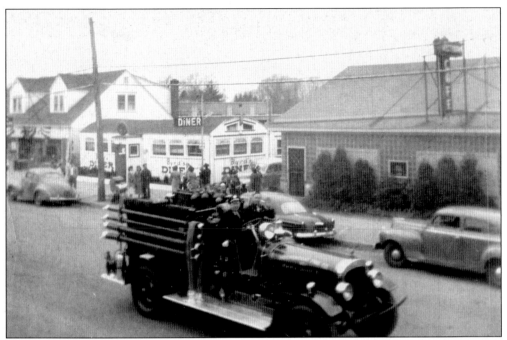

In another 1953 parade picture, the Victory Cafe, which formerly was the Betterment League's Community Hall, can be seen up the street past Main Street Hardware and Byrd's Diner. (Courtesy Virginia Harris and the Bechler family.)

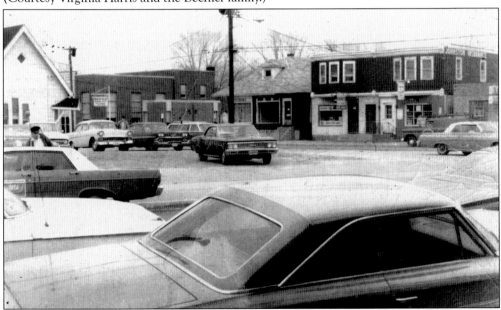

This is North Forklanding Road before the urban renewal project. On the right side of the photograph are the Taxi bar (right), Harris' News Agency (second from right), Johnston Insurance (third from right), and the Republican Club (bungalow). On the left side of the photograph is the Bethel Pentecostal Church. Harris' News Agency moved to South Forklanding Road in the early 1970s. The store was run by Grace and Bob Skillen. (Courtesy Virginia Harris and the Bechler family.)

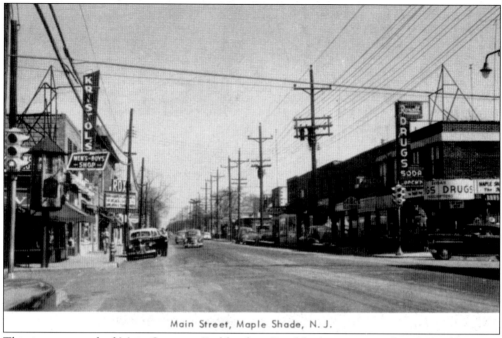

This is a postcard of Main Street at Forklanding Road looking east in the 1940s. (Courtesy Dennis Weaver.)

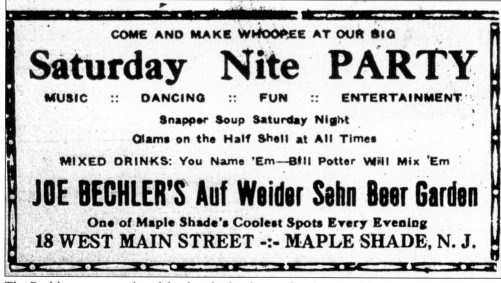

The Bechlers are remembered for their barbershop and perhaps Bechler Better Bread, but does anyone remember their beer garden on Main Street? This is an advertisement from the *Maple Shade Progress* newspaper.

Seen here on Main Street looking south near Lippincott Avenue is a 1936 Chevrolet coupe that belonged to Frank Brooks Sr. These billboard signs are where the metropolitan building and Mr. Geiger the plumber's house would be built. (Courtesy B. Franklin Brooks.)

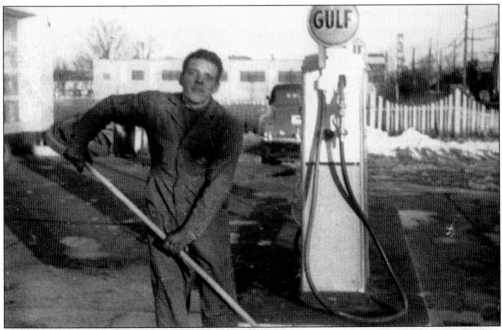

This photograph shows Walt Baker, an employee at Frank Brooks's Gulf station, which was located on West Main Street and North Lippincott Avenue. Note the Acme sign in the background. The Acme Supermarket was located in the building presently occupied by Smith Brothers pharmacy. (Courtesy B. Franklin Brooks.)

This photograph, taken in the late 1940s or early 1950s, shows someone shoveling snow from Brooks's Gulf station on West Main Street and North Lippincott Avenue. The Arthur Cutler House is in the background. (Courtesy B. Franklin Brooks.)

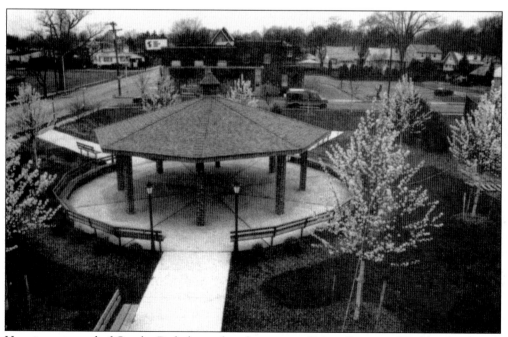

Here is a postcard of Gazebo Park, located at the corner of Main Street and Forklanding Road. The postcard is available from the Maple Shade Rescue Squad. (Courtesy Dennis Weaver.)

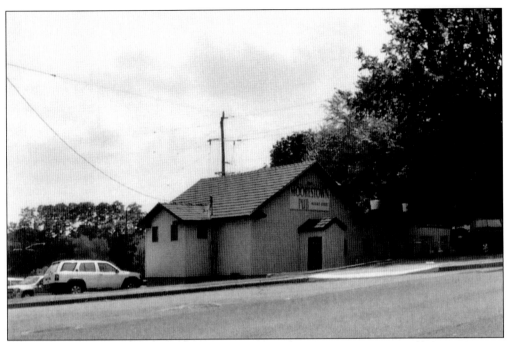

The Moorestown Pub was actually located in Maple Shade, and was last owned by Tom Bowers. It was once known as Mary's Café. It is set to be razed for a road project in 2008. This photograph was taken by Dennis Weaver in 2003.

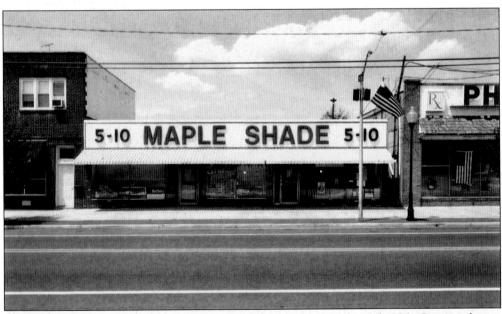

It was for many years a Ben Franklin Five and Ten, which opened in July 1961. Prior to that, it was a James store. Today it is the Maple Shade Five and Ten store. This photograph was taken by Dennis Weaver in 2003.

Eight
BUSINESS AND INDUSTRY

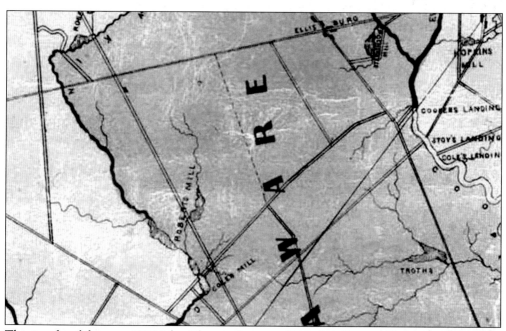

This is a detail from an 1846 John Clement Jr. map of Camden County. Today a road formerly called Poplar Landing Road intersects Main Street and is called Forklanding Road. It still leads to where the landings were. In 1846, the Heulings family had a lumber and planing mill and wharf at Fork Landing, which was located just over the bridge into Cinnaminson. In this 1846 map, the Burrough family's gristmill is owned by the Coles family, and a part of the remaining old road to Market Street is still seen nearby. This road was replaced by today's Main Street. Enoch Roberts's sawmill was located just south of Route 38 at Mill Road, and two other mills owned by the Roberts family were at Colestown. Roberts Mills Apartments are now in that area. (Courtesy Dennis Weaver.)

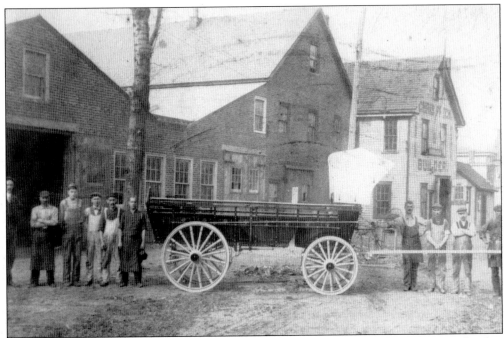

The Frech wagon works were started in 1847 by Christian Frech and was among the first industries here. William Frech and partner, John Parker, greatly expanded the company and specialized in market wagons for carrying baskets. Later they made circus wagons and truck bodies. The Frech Wagon Company's invention of the "cut under" front wheels put it several years ahead of the competition. This allowed the wagons to turn in a smaller radius, which was ideal for tight city streets. (Courtesy Dennis Weaver.)

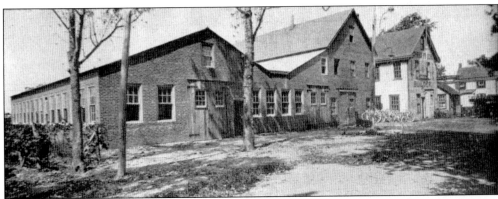

After the Charles F. Shuster tract was revised to have Spruce Avenue go through Christian Frech's land up to Main Street, the Frech wagon works settled along it. The old Chris Frech Builder building was moved from Main Street to Spruce Avenue. A huge fire in June 1940 destroyed all but the far left building, which is now an automobile repair shop. (Courtesy Maple Shade Historical Society.)

Seen here is an undated William Frech Wagon Company brochure.

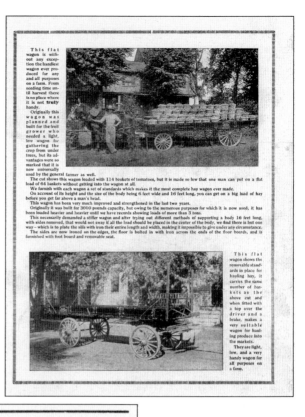

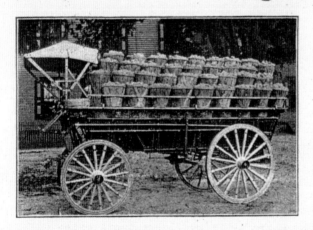

This is a 1907 advertisement featuring William Frech Wagons from a 1907 Chester Township directory.

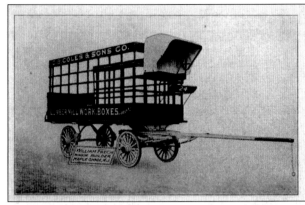

Charles B. Coles was born in the Alden Park section of town and would come to own that land. He became very wealthy as the owner of C. B. Coles and Sons Lumber Company in Camden. Here is a Frech wagon advertisement from a Camden business directory showing a wagon built for his lumber company by the Frech Wagon Company. (Courtesy Dennis Weaver.)

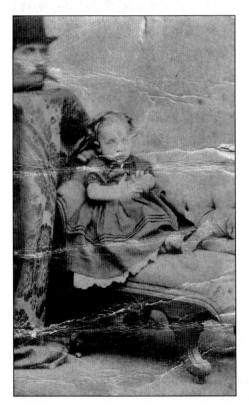

Here is a picture of Christian Frech with baby Laura Frech. (Courtesy Karen Mennel Pike.)

Pictured here is William Frech, son of Christian Frech. (Courtesy Karen Mennel Pike.)

Walton, Lippincott & Scott,
CABINET MAKERS.
No. 413 Walnut Street, Philadelphia.

Our Establishment is one of the oldest in Philadelphia, and from long experience and superior facilities we are prepared to furnish good work at reasonable prices.

We manufacture fine furniture, and also medium-priced furniture of superior quality. A large stock of furniture always on hand. Goods made to order.

Counters, Desk Work and Office Furniture for Banks, Offices and Stores, made to order.

JOS. WALTON. J. W. LIPPINCOTT. JOS. L. SCOTT.

Joseph Walton, who, according to an 1876 atlas map, was a brick maker, was actually not one at all. The brickyard was run by John Muffett and his son. Joseph and Lydia Walton did inherit the land though from her family, the Lippincotts, and sold or bargained the yard to the Muffetts. Joseph Walton and Lydia's brother Joseph W. Lippincott were, by trade, furniture makers and had a shop in Philadelphia. (Courtesy Dennis Weaver.)

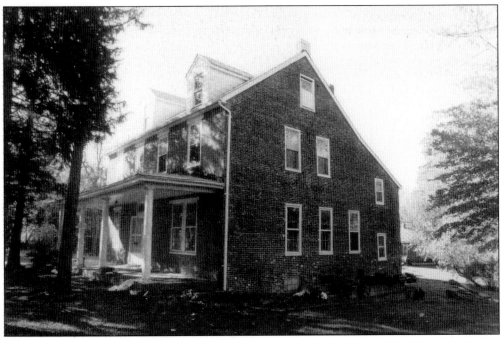

Located at 919 East Main Street is a brick house built for John Muffett and his son Robert. It was originally a double house that was built about 1858 on the former yard of Maple Shade's first known brick maker, Thomas Lippincott. The Muffetts soon owned the house and brickyard, which they bought from Lippincott's sister Lydia Walton and her husband, Joseph. The brickyard was called the John Muffett and Son Brick and Tile Yard, and was later owned by Augustus Reeve and John S. E. Pardee. (Courtesy Mrs. Senior; photograph by Paul D. George.)

AUGUSTUS REEVE
RED BRICK

RAIL SHIPMENTS DIRECT FROM FACTORY

Works: Maple Shade, N. J. Office: 31 Market St., Camden, N. J.

FULL LINE OF BUILDERS' SUPPLIES

Sewer Pipe, Flue Linings, Fire Brick, Fire Clay

EASTERN PHONE, 378 BELL PHONE 378 A

Maple Shade had two brickyards. The Muffett's brick house is still located on Main Street. In 1900, Reeve bought additional land on the south side of the Moorestown and Camden Turnpike from John R. Mason and expanded the clay pits across Main Street. Narrow gauge rail tracks crossed Main Street, about where the Route 73 south ramp now is, to carry the clay by rail carts pulled by horses or mules. The front yard shut down during the Depression. This is from a 1907 Chester Township directory.

This is an 1881 photograph of Theodore Sauselein Sr.'s original house He later built a much larger house on North Pine Avenue. (Courtesy Maple Shade Historical Society.)

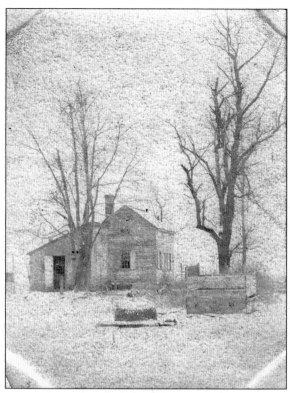

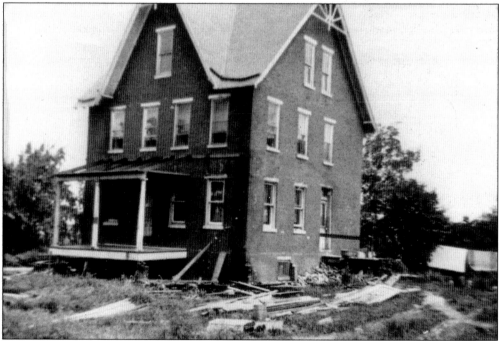

Two large brick houses were built on Sauselein Lane, now North Pine Avenue. One was built by Theodore Cash Sauselein. The other, seen here, was built by his brother George Sauselein. (Courtesy Maple Shade Historical Society.)

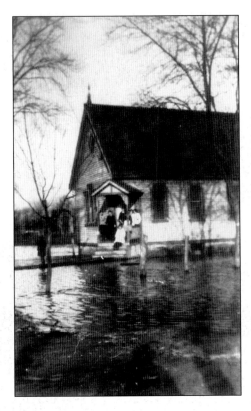

A Methodist Church was built on Elam Brubaker's land at the northwest corner of Main Street and Forklanding Road in 1891. It soon became a Union Church. The Congregational Church formed and used the building then built a new church on Theodore Avenue, which was dedicated in 1919. The Brubakers then used the old Methodist Church as their uniform factory business, E. Brubaker and Sons, previously of Philadelphia. The company was later named J. Brubaker and Sons. Business grew and the Brubakers built a large factory on North Forklanding Road. The building was later used by the Edsamm Screw Machine Company after the Brubakers moved their uniform factory to Main Street and Chestnut Avenue. These photographs show Brubaker factory workers during a flood when the church was used as their uniform factory. (Courtesy Maple Shade Historical Society.)

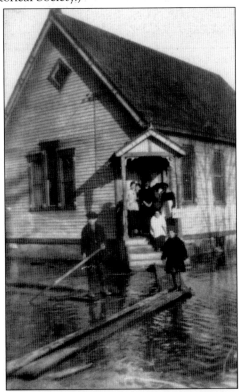

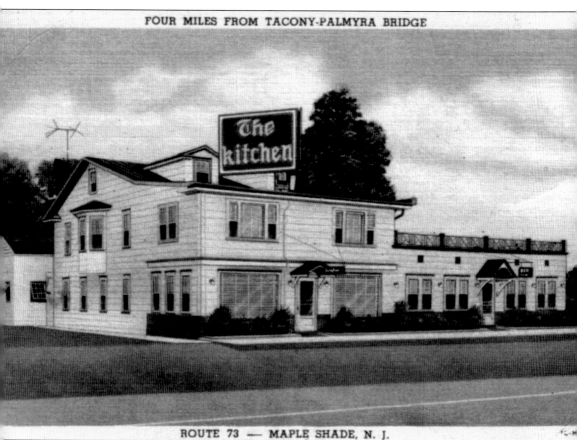

The German Kitchen restaurant was located on Route 73 north of Main Street. When it was sold in June 1983, the name was changed to the Restaurant Lounge, but the restaurant had been on the same site since the 1920s and owned by the Michel family for more then 60 years. It held the last original liquor license in the township. The German Kitchen was started in a house at the same location in the 1920s by Marie Michel and her friend. After a few years, the friend died and she took over ownership. During World War II, the Michels dropped the word "German" from the name and the restaurant simply became the Kitchen. In 1965, it again became the German Kitchen and 10 years later, it was changed to Michels. They used to have a German band once a month but, over the years, their food became more American and they became known for their deviled crab. (Courtesy Paul Altobelli.)

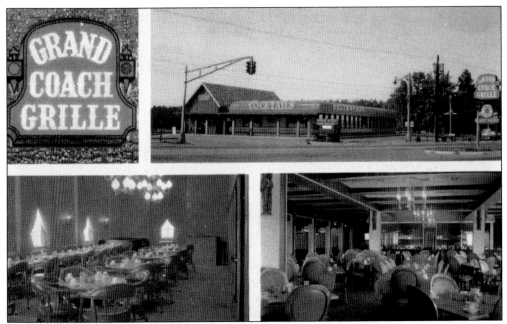

The Grand Coach Grille was on Route 73. A large-scale model train set ran around a track inside the restaurant. (Courtesy Paul Altobelli.)

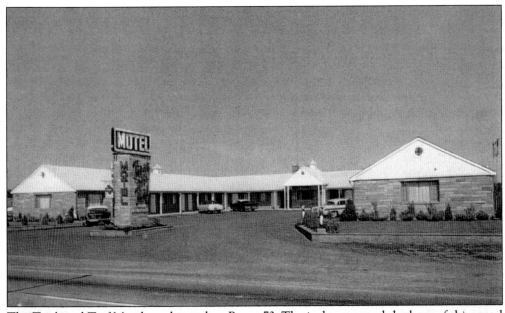

The Track and Turf Motel was located on Route 73. The jockeys around the lawn of this motel hint at what a few of Route 73's motels advertised. Also the word "track" in the motel's name indicated that it was a place to stay for visitors coming to the Garden State Park racetrack. (Courtesy Paul Altobelli.)

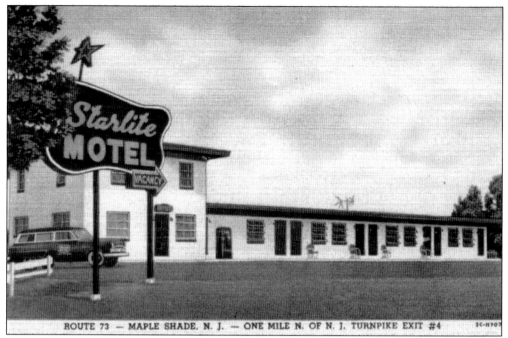

This is an early postcard of the Star Lite Motel located on Route 73. It was advertised as "One mile north of New Jersey Turnpike Exit #4." (Courtesy Paul Altobelli.)

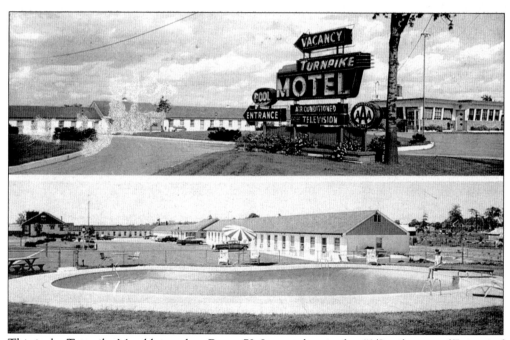

This is the Turnpike Motel located on Route 73. It was advertised as "1/2 mile west of Exit #4 of New Jersey Turnpike. 6 miles east of Philadelphia Bridge." (Courtesy Paul Altobelli.)

Platters—Dinners
Specializing In Seafood Platters

We Are Now Taking Reservations For Fall Weddings and Social Affairs . . . Private Rooms for Private Parties

CHUCK SWEENEY
Entertains Every Night Except Monday
Featuring BETTY LANE
Comedian and Vocalist Direct From The Coast
This Week-end Only — GLORIA HUDSON, Vocalist

BERT'S OLD MANSION
PHONE, MERCHANTVILLE 8-9382
324 EAST MILL ROAD, MAPLE SHADE, N. J.

Bert's Old Mansion, the old Barlow Mansion, was located at 324 East Mill Road. It was owned by John and Bertha Czyzewski. They served all types of food but their specialty was seafood, such as crab cakes. This advertisement is from the *Maple Shade Progress*.

Joseph Schlitz owned several buses that ran from Moorestown to Camden. His bus garage and repair shop was behind a house near the corner of Mill Road and Sunset Avenue. He also built a bus terminal on the northwest corner of Main Street and Pine Avenue, which later became a skating rink, the Elite Bakery, and electrical contractors Dickman and Hansen. (Courtesy Paul W. Schopp.)

Ten
NOTABLES

Maple Shade was a hot spot during the 1920s. People would come from all over to go for a plunge in the Pennsauken Creek. Owned by August and Margaret Hagelin, Stiles Park was at the North End of Stiles Avenue. They rented canoes, played music on the loudspeakers, and sold hot dogs. Their daughter Dorothea Faulkenstein still tells stories about canoeing down the creek with her brother Bud. (Courtesy Dorothea Faulkenstein.)

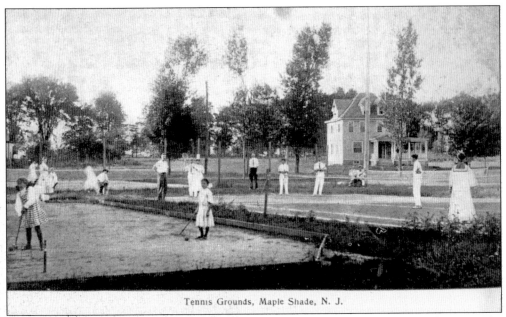

This is a 1909 postcard of the Maple Shade Lawn Club. Kids are playing croquet and tennis. The club was located at Forklanding Road and Linwood Avenue. The property at 19 East Linwood Avenue is pictured in the background. (Courtesy Maple Shade Historical Society.)

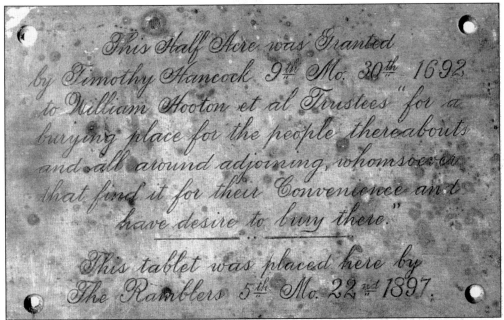

This plaque came from the larger of two known graveyards in Maple Shade. The inscription on the tombstone of Thomas Wallis, who died 1705, reads: "Who ever thou art that passethby, Look on this place, see how we lie; And for thy soul be sure care take, For when death comes, 'twill be too late." (Courtesy Maple Shade Historical Society.)

Built in 1939, this water tower structure existed until the fall of 2003. It was located on North Cedar Avenue. The welcome to Maple Shade message was visible upon entering and exiting the town. The highlight of the holiday season during the 1950s and 1960s was the large lighted star at the top of the tower. (Courtesy Maple Shade Historical Society.)

Many people, attracted by the promising advertisements, bought land from Barlow and Company. Just $5 per month "will put you on the road to prosperity." (Courtesy Maple Shade Historical Society.)

FIG. 4. *Bothremys barberi*, spp. A (ANSP 15902), Merchantville Formation, New Jersey, dorsal view of carapace.

Maple Shade Industrial park sits on clay accumulations that date back eight million years. The sediments exposed here were once part of the ocean floor. In the late 1800s, these clay beds were being commercially developed by the brickyards. During excavations fossils were found from the dwellers of that ancient sea. Perhaps the single most significant find from is this sea turtle, which has been assigned its own subspecies. It was found in 1945 by Albert Jehle and Henry B. Roberts, who were young amateurs trained by Dr. Horace Richards, a leading paleontologist of the Academy of Natural Science. This turtle was a member of a group, mostly extinct today, that pulled their necks and heads inward to the side rather than straight back. (Courtesy Field Museum Press, Field Museum of Natural History, Chicago.)

Sixty-four species of snails and clams, along with fish teeth, crab claws, bone and wood fragments, and ammonites were found in the 1890s in the clay pits. Many years of continual digging have brought numerous finds including the ones pictured here. Fish are represented mostly by shark teeth (upper row and bottom right), and fish teeth (two central, bottom row). A partial shark backbone is at bottom left. (Courtesy Hank Baron.)

This September 1954 photograph, looking east from Pine Street, shows the abandoned brickyard that was owned by Augustus Reeve and John S. E. Pardee. At the far left is the chimney of the Graham Brick Yard, which was still in operation. (Courtesy Joseph Gudonis.)

Across America, People are Discovering Something Wonderful. Their Heritage.

Arcadia Publishing is the leading local history publisher in the United States. With more than 3,000 titles in print and hundreds of new titles released every year, Arcadia has extensive specialized experience chronicling the history of communities and celebrating America's hidden stories, bringing to life the people, places, and events from the past. To discover the history of other communities across the nation, please visit:

www.arcadiapublishing.com

Customized search tools allow you to find regional history books about the town where you grew up, the cities where your friends and family live, the town where your parents met, or even that retirement spot you've been dreaming about.